American Photography: *Past into Present*

Prints from the Monsen Collection
of American Photography

selected and with an introduction by
Anita Ventura Mozley

Seattle Art Museum

Distributed by the
University of Washington Press Seattle and London

ISBN (cloth) 0-295-95508-2
ISBN (paper) 0-295-95509-0

Printed in the United States of America

front cover
Minor White
Front Street, Portland, Oregon 1939
silver print

back cover
Lewis Baltz
from the portfolio,
*The New Industrial Parks Near
Irvine, California* 1974
silver print

779.09730740/9777
A

The Monsen Collection of American Photography was formed with the aim of bringing together works that would cover the history of photography in America. How well Dr. R. Joseph Monsen and his wife, Elaine, have succeeded is clearly revealed in the exhibition which this catalogue represents. The major developments and leading photographers are represented, but so too are less well known individuals whose works have merit.

Affecting their broad goal and making the Monsens' collection truly distinguished is the element of aesthetic judgement. Consistently, they have based their selections on the artistic merits of the work being considered. Well-known classic images are enhanced by the presence of refreshingly unfamiliar prints that demonstrate the great range of the photographic medium. A collection so chosen also helps us discover the artistic values in earlier photographs we might otherwise pass by as mere historic relics.

Thus the Monsen Collection is a remarkable achievement that gives the viewer a wide-ranging overview of American photography and further reinforces the acceptance of photographs as works of art.

We are grateful for the opportunity to present this exhibition.

I wish to thank all whose cooperative efforts have brought about the organization of this exhibition and production of the catalogue.

Particularly, Anita Ventura Mozley, Registrar and Curator of Photography, Stanford University Museum of Art, who selected the exhibition, developed its theme and wrote the catalogue.

Professor Douglas Wadden, Graphic Design Department, University of Washington, not only designed the catalogue but has provided invaluable advice and encouragement to us all.

Mounting, matting and framing over 300 photographs has been ably carried out by Ms. Mary Scott, Mrs. Martha Fletcher and Michael Davidson. The installation was designed and executed by Neil Meitzler.

Willis F. Woods
Director, Seattle Art Museum

Michael Bishop
Untitled No. 2306 1974
RC print, toned

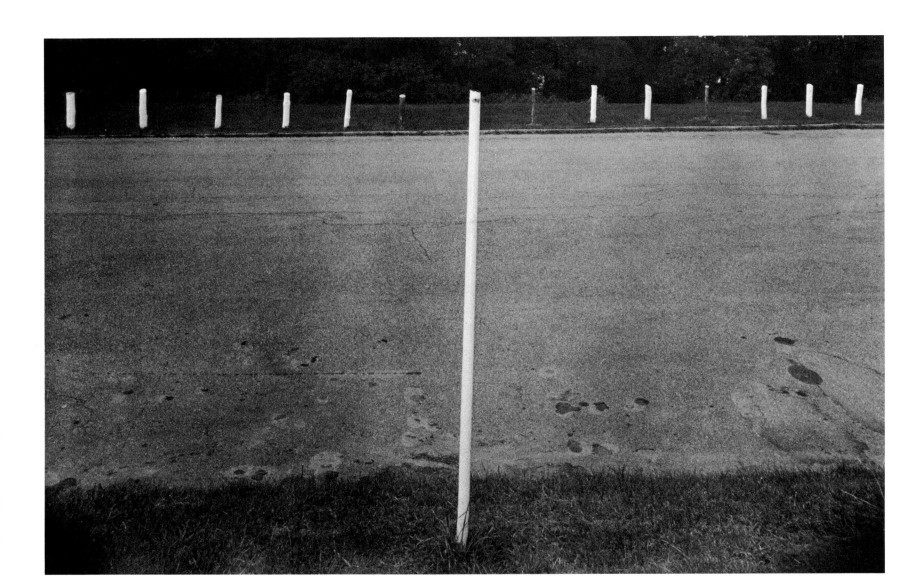

Contents

Minor White
Front Street, Portland, Oregon 1939
silver print

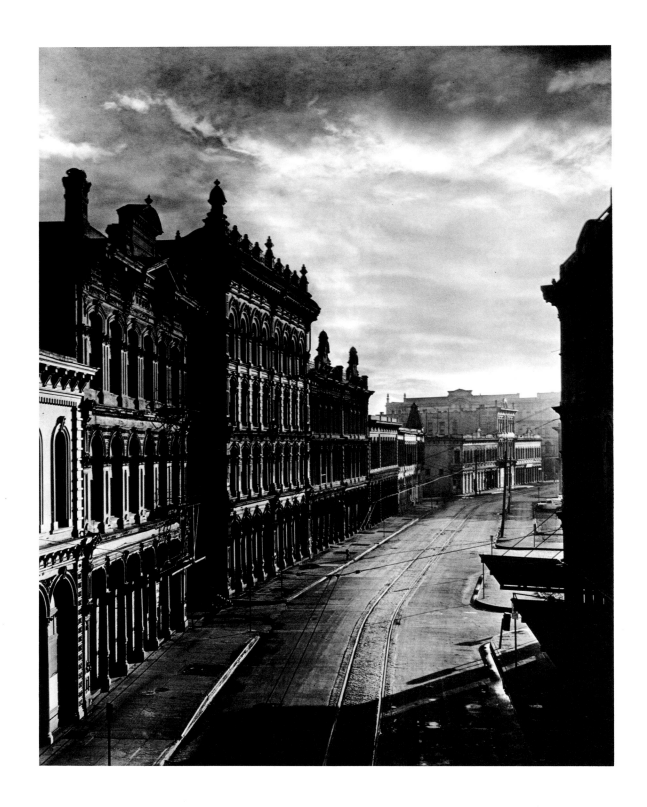

Introduction

"Deliver us this day our daily bread, and make of this land a photographic nation. . ."

—variant of the Lord's Prayer, from unpublished dream literature

The Monsen Collection of American Photography, a growing collection, has been stopped, caught in full course, by the cataloguer and the exhibition director for its presentation in this bicentennial year. Caught in course as it is, it is, nonetheless, a collection already so extensive that several historical surveys of photography in America might be made from the various themes that the photographs in it provide.

In almost all of these themes, around which this catalogue is planned, a history of the medium as it has been used in this country is set forth. One sees, first of all, the nature of the struggling beginnings, when the image, although sometimes barely there, speaks clearly to its purpose as talisman, means of recognition, statement of fact, expression of desire or of pride. In the range of photographs devoted to several of the themes, one is able to follow the changes (not always advances) in processes and techniques, and the changes in styles that these techniques admitted. One can recognize the individual workers who pressed available technique beyond what it yielded to a common vision and so created a new style. The influence of the aesthetics of other media, and how such influence has bent photographic style in directions not inherent in the medium, is evident, and so is the counter-influence of the reassertion of photograph's early representational intention. These influences have been expressed contemporaneously: compare the illustration by Clarence White, Photo-Secessionist and lecturer on photography at Columbia University, to the portrait by E. J. Bellocq, a commercial photographer of New Orleans, for instance.

And beyond technique, beyond aesthetics and particular purpose, indeed governing them, one can see how the course of life in this country, during the one-hundred and thirty-seven years since Daguerre's publication of his invention and Fox Talbot's announcement of his method of making "sun pictures," has inflected photography by the type of subjects it has provided. In times of national crisis—war, depression, natural disaster—the subject has been so commanding that it must be met head-on, so pressing that relaxation into artifice can not be admitted. The story must be told straight, and all the knowledge of art devoted to that straight telling. In such times, circumstance has itself brought style to birth. In times of greater ease, or in the hands of photographers who have resisted the command of the assertive subject (Weston, for instance, is one whose photography has served no other demands but the ones he put on it), nationality is not so readily identifiable, and the photograph is part of a system of image-making that presents its subject less emphatically; the individual photographer's expression is felt more strongly.

Photography in this country, or in any country in which it is put to a wide range of purposes, speaks so broadly, so directly and with such permeating frequency as to defy definition in any collection. Unless, perhaps, the collector be also a customer of photomatiques, a clipper of arresting AP wirephotos, found mainly on the sports pages of the New York *Times*, a student of most-wanted portraits on Post Office bulletin boards, as well as a connoisseur of discarded Polaroid images found at deserted viewpoints off national highways.

The emphasis in this collection is, rather, on the work of those photographers who have come to be known as fine practitioners of their art. Although the production of a photographic print does not necessarily imply the use of a camera and lens, most of the prints in this collection were made in that way. While the emphasis is on the acknowledged master photographers, the collection does not exclude those photographers unknown to today's audience for photography, an audience which is accustomed to finding in photographic prints a significant expression of an artist's intention. Carleton E. Watkins, Eadweard Muybridge, Alvin Langdon Coburn, Stieglitz and his circle, Berenice Abbott, Minor White, Eugene Meatyard and Emmet Gowin, among others, are here, but so also is the family friend, the maker of souvenir views, and the portraitist whose name does not figure in the bold type on the studio mount. Still, the criteria established by the former are carried over to the work of the latter, and all works judged by what now might be called an eye trained to sense what, in photography, is admissible as art.

We presently admit a great range of expression to that category. Topographical views of the nineteenth century, those made by Timothy O'Sullivan, for instance, for the Government surveys of the Western Territories in the 1870s, are presently seen and appreciated more often by eyes accustomed to finding significance in the relation of positive to negative spaces than those used to examining such photographs for the geological and geographical information that they were taken to convey. This is a recent development in our vision. We do not deviate, however, from nineteenth-century criteria in our appreciation of those early views of previously unknown landscape that were taken with a clear understanding of rules governing the picturesque representation of nature. They are part of a continuing tradition of picture-making, a tradition inherited from its immediate ancestors in the graphic arts, and one that is still strongly felt in the work of some fine twentieth-century landscape photographers.

We cannot view photographs of the past with the eye of the past. We find what we know in what we see, and since those photographs were taken, we have come to invest well-made but unpretentious photographs of the past with an order of meaning far beyond what was evident to a nineteenth-century professional photographer who strove at most for niceness of viewpoint and proficiency of technique. (And I know of no amateur photographer of this country in the nineteenth century whose work had higher aspirations. In portraiture, as well, this country did not produce, to my knowledge, a body of work comparable in its preconception to that of Julia Margaret Cameron or Lewis Carroll in England.) Thus, we can discover in an album by J. H. Crockwell, *Souvenir Views of Park City, Utah*, a photograph of a *Picnic Party at Brighton Lake* that does more than record the event, that expresses, rather, the brave gaiety of the little party, dressed in fine clothes and drinking wine, in a landscape that threatens a call for heroic action. Such photographs, which we see with a sense of revelation, invite metaphor, and we, after all the battles that have been fought to admit this metaphorical interpretation of the photograph, stand ready to supply it as we can.

Comparison of other views in the *Park City* album to the work of acknowledged masters of the medium can be made: Mr. Crockwell's view of the Ontario mine gives much the same impression of human and mechanical energy invested in it, as wide a range of fine information-giving detail, and as comprehensive a sense of the time and the place as Carleton E. Watkins' view of the *Nevada Mill*, which was taken on a much larger plate, does of its subject. The photographs of Wilhelm Hester, who worked on the Seattle waterfront at the turn of the century, making his living as a ship portraitist and incidentally taking pictures of masters, mates and crews, portraits made either on deck or, more rarely, in the master's cabin, are another example of work by a photographer who, although presently little known, will, upon wider acquaintance, take his place in the enlarging gallery of photographers who accomplished a body of work of fine quality and significant expression.

From the days of the daguerreotype and the calotype, of which the United States was informed in 1839, the year of their publication, this country has contributed substantially to the growth of photography, both materially and in ways less easy to measure, through its strong appreciation of the medium. In his *The Daguerreotype in America*, Beaumont Newhall reports that Samuel F. B. Morse, the painter and inventor, president of the National Academy of Design, persuaded the members to elect Daguerre an honorary member in 1839, a

recognition of photography by an official body of painters that Mr. Newhall cited, in 1968, as unique. American daguerreotypists so improved the mechanical, chemical and optical processes involved in making a daguerreotype that "The American Process" was advertised by the daguerreotypists of France and of England. As in France, this government has fostered and used photography for civic purposes, most notably in documenting the Western surveys of the 1870s and in compiling the record of life in this country made during the 1930s by a group of photographers working under the aegis of the Farm Security Administration. Patronage has come, too, from industry and from private individuals, often for work that has had international consequence. When Leland Stanford asked Eadweard Muybridge to photograph his fast horse Occident, could either of them have imagined that the experiments would lead, eventually, to the synthesis as well as the analysis of motion—to the motion picture? Alfred Stieglitz, born in Hoboken and educated in Berlin and England, created an equally stirring revolution when he insisted, in New York City in 1902, that the photograph be given equal status with other visual media as a way of making art. He thereafter published criticism, theory and polemics in support of his position; he remains today, long after his battle was won, the most influential champion of the fine art of photography that the world has known. Stieglitz's important work was, in part, a reaction to the general aimlessness introduced by George Eastman's Kodak in 1888: you pressed the button and the Eastman Company did the rest. Stieglitz, in effect, delivered photography again into the hands of the real amateurs of the art.

Americans have always wanted much of photography, from the mid-1850s, when there were more daguerrean portrait studios on Broadway in Manhattan than there were in all of London, to the present, when this country exhibits, studies and collects photographs to an extent undreamed of (except, perhaps, by Beaumont Newhall) twenty years ago. And Mr. Newhall is himself, in his international role as the leading historian of photography of our time, an example of an influence that leads to change in the field of photography as decisive as "The American Process" was in the days of the daguerreotype.

From the viewpoint of today, the history of photography is certainly not a static one. It is increasingly complicated. Only now are we beginning to sort out newly discovered material, and have widely available to us reprint editions of source material. The formulation of the history changes as the present picture is modified by these discoveries and this information. Only now, for instance, is the important relation between

photography and nineteenth-century concepts of realism being studied, and only now can we locate, because of the increased number of people working in the field, biographical information that makes possible an understanding of a life devoted to making photographs.

To discern the specifically American figure in the whole complicated fabric becomes more and more difficult. A collection such as this helps to illuminate it. In the brief introductory texts to the picture sections that follow, a few strands pertaining particularly to this collection have been picked out. They are the ones that are possible to cite as occurrences; the American figure to which they lead, the meanings of the pictures which they helped to produce, is not so much a part of photographic history as it is of the history of our culture. The photographs fill out this history, both as an intimate record of our past and as a revelation of our present.

Anita Ventura Mozley
Menlo Park, 1976

J. H. Crockwell
Picnic Party at Brighton c. 1890
albumen print

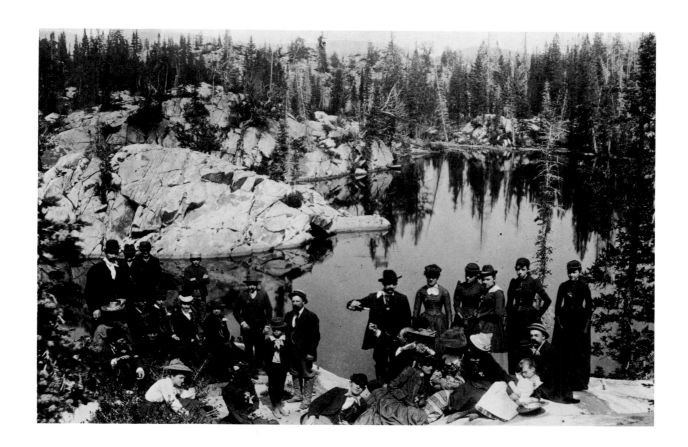

Arnold Newman
Elaine and Joseph Monsen 1975
silver print

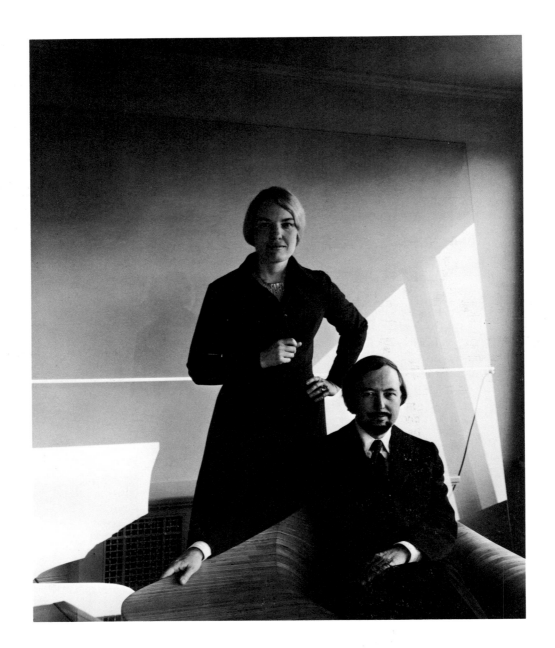

The idea for this collection began, as have so many ideas, over lunch at the Harvard Faculty Club. Art historian, James Ackerman, who knew of our other collecting interests suggested to me, "Why don't you begin collecting photography?" My response—like that of most of our friends in Seattle when later we tried to show them our collection—was, "I don't really care for photography." Ackerman's reply to me was reminiscent of *The Late George Apley*, J. P. Marquand's novel of the Boston Brahmin, who replied when asked why he collected Chinese bronzes that it was not because he liked them—he never had—but only because the Boston Museum needed them. Thus I was curtly told, it was my duty to collect photography. Coming from a Puritan tradition, I naturally succumbed to such logic.

During that academic year, 1968-69, Elaine and I were visiting at Harvard, on leave from the University of Washington—she on a post-doctorate grant in Nutrition and I as a Guggenheim fellow in Economics and Business. There was in those days, one art dealer in Boston who also showed photography, Carl Siembab. At about the same time in New York, Lee Witkin began what has become perhaps the most successful photographic gallery in the country. Without these early dealers and their subsequent colleagues, collecting would have been even more difficult, for we had to educate ourselves to know whom we wanted to collect and which prints we wanted to buy. A few books by Beaumont Newhall, John Szarkowski, and Robert Taft were indispensible at the outset. Until later, when we had the great pleasure of knowing and learning from Van Deren Coke and, more recently, Anita Mozley, we felt the lack of scholarly guidance. We have, therefore, continued to use the same aesthetic criteria we have used in collecting oriental and contemporary art: did the image strike us as compelling and did it, at least in its time, create any new aesthetic ideas. We have felt these criteria to be as important with historical as with contemporary images.

While our photographic collection now ranges beyond just American material, we felt early on that in the American field we might hope to learn enough and have enough self-discipline to create a collection that would show most of the major photographers who worked in the American stream. Whether or not there is a distinct American "eye" or aesthetic that runs throughout the history of photography in this country will surely be debated. We feel there is such an aesthetic and that it is apparent in the photographs here.

We have, by now, benefited and enjoyed the insight of a number of museum curators, collectors, scholars and dealers: Charles Cowles, Robert Monroe, Davis Pratt, John Coplans, Jack Glenn and the Light Gallery to name only a few. In particular, Douglas Wadden has not only been one of our few early photographic compatriots, but has been a driving force behind this catalogue and, indeed, the show itself. Anita Mozley is not only an important scholar on photography, who has selected this show with her own very special eye, and who has written here an exceptionally insightful text, but is, above all, a beautiful human being. Coming to know her has helped compensate for the all-too-frequent periods of frustration, disappointments, and even anguish that are inevitable in collecting—travail that perhaps only other collectors may understand. Willis Woods, Director of the Seattle Art Museum, originated the idea for this show and has been steadfast in personally overseeing it. Best of all, for us, he has been a friend who has shared our delight in the photographic image. We hope these images will, for others, create equal aesthetic pleasure.

Joseph & Elaine Monsen

Seattle, Washington

Unknown
The Scottish Textile Worker, Damariscotta, Maine
c. 1843
tinted daguerreotype

From the daguerreotypes of the 1840s to the portrait photographs of the present day, we find portrait photographers walking the line between idealization and unembellished representation of their subjects. When the Boston daguerreotypist, Albert Sands Southworth, said of the making of a portrait that it "should be the aim of the artist-photographer to produce in the likeness the best possible character and finest expression of which that particular face or figure could ever have been capable,"[1] he was defining the idealizing impetus. But he added: ". . . in the result there is to be no departure from truth in the delineation and representation of beauty, and expression, and character," thus supplying the other horn of the dilemma of the traditional portrait photographer.

From the past into the present, some American photographers have walked this straight and honorable line successfully: the unknown daguerreotypist of the *Two Young Brothers* of the 1840s, as well as Berenice Abbott in her portrait of *James Joyce* in Paris in 1928, and Paul Strand in his portrait of a *Young Boy* of the French countryside of 1951. Others have deviated from the traditional path, some in the direction of what we sense as representation so accurate that we can accept it as document (Walker Evans, for instance, in his *Alabama Farmer's Wife*, made for the Farm Security Administration and first published in the book produced by James Agee and Evans in 1941, *Let Us Now Praise Famous Men*). There are also portraits on the following pages that pronounce more clearly the photographer's aesthetic, which puts his subject in a light different from that in which it might be seen by any other eye. The juxtaposition of these two impulses, impulses that are a continuing thread in the fabric of American photography, often allow us to see both the subject and the photographer more clearly, and also make us aware of particular social or historical circumstances that both occasion the making of the photograph and contribute to its meaning. The comparison of the Clarence White illustration to E. J. Bellocq's portrait of a New Orleans prostitute has been cited as an approximately contemporaneous example of these two impulses.

The pairings of the portrait and group photographs that occur on the following pages have been suggested for other reasons as well. In some cases, it is the similarity of formal arrangement devoted to very different subjects that invites the comparison. Take, for example, these two paired portraits: that of *Helen Blythe*, a young woman of San Francisco who sat for the operator of the Elite Studio of San Francisco, and that of *Hattie Tom*, a young Apache woman, who was photographed by F. A. Rinehart as part of a series of portraits of American Indians. It is a comparison

possible only in a country that has been recently a colony and a wilderness. We are struck, I think, more by the similarity of their questioning responses to being fixed before the camera, than we are by the obvious cultural differences that their dress, their names and the reasons for their being photographed evidence. This cannot be carried too far; it is dangerous and misleading to extract photographs from their social context. Steichen taught us that lesson in his *Family of Man* exhibition, an exhibition that was probably attempted, in the early 1950s, to somehow heal war wounds. But I think that it is true that photographs in which we sense very little interference between the camera and the subject, particularly well-made studio photographs, do offer this invitation to explore personality, unequipped as we may be, in the case of *Hattie Tom*, to do it adequately.

Other studio photographs invite us to compare types of subjects, and this, if done thoroughly and exhaustively, would define the portrait business in photography as it has existed since the daguerreotype; we today all know something about the aspirations of at least half of the wedded couple from the name of the photographer that appears under the bride's picture in the local newspaper. When the actor *Henry E. Dixey* took himself to the studio of Sarony in New York, he knew that he was going to a photographer of celebrities, and that the swash Sarony signature printed in red on the studio mount would not only assure him of the dramatic image he wanted of himself, but would, by its social cachet, enhance his career. The young Dr. Tilson of Salt Lake City, on the other hand, was not seeking celebrity when he went to the little-known photographer, T. E. Hinshaw. Nevertheless, he was as suitably memorialized, both as an individual and as a type, and his role in American society is as clearly given as any that Henry E. Dixey might play on the stage.

Does it seem odd to face *John Pierpont Morgan, Esq.*, as seen by Edward Steichen, with Edward S. Curtis's *Nayénezgani*? When Steichen made his portrait of Morgan in 1903, the financier was chief of one of the most powerful banking houses in the world, an enthusiastic yachtsman and a notable collector of books, pictures and other art objects. The photographer, Steichen, had recently returned to this country from England and from Europe, where he had been elected a member of the British avant-garde photographic society, The Linked Ring, and had shown his paintings and photographs in Paris. He had returned to New York in 1902; in that year he showed fourteen of his photographs in Alfred Stieglitz's exhibition, *American Photography arranged by the Photo-Secession*, a name which

14

came to stand for a group of photographers who asserted the expressive possibilities of photography, who claimed it to be an independent art form.

Curtis, of Seattle, Washington, had been making photographs of American Indians since 1900; his goal was to make "transcriptions for future generations that they might behold the Indian as nearly lifelike as possible as he moved about before he ever saw a pale face or knew there was anything human or in nature other than what he himself had seen."[2] His work was never exhibited at the Little Galleries of the Photo-Secession in New York. Curtis's work was published, instead, over a period of twenty-three years, and the publication was made possible by J. P. Morgan's underwriting it with a sum of $75,000. (As a footnote to these brief biographical extracts, I might add that Steichen, at the end of his varied career, became director of the Department of Photography at the Museum of Modern Art in New York; Curtis's last known photographic work was in Hollywood, where he made stills for Cecil B. De Mille's *The Ten Commandments*. Such are the possibilities of a life devoted to photography in this country.) In any case, history provides a justification as strong as formal arrangement for this comparison of photographs.

In some instances, the juxtapositions must stand on the evidence of the photographs themselves. I can hardly transcribe the similar sensations that emanate, for me, from Les Krims's *Mom's Snaps* and Emmet Gowin's *Barry, Dwayne and Turkeys*. To attempt it would be to say that the two photographs seem to be about the same subject, about some absurd aspect of growing up, and about the perilous escape we must make from childhood into something else.

Photographs that contain elements of theatricality, elements that suggest the title "tableaux," are comparable: Fox & Symon's *12th Ward Meat Market* and H. S. Klein's *Drama*. In one, the trees are pulled back, in the other, curtains. Both groups have been arranged in a hierarchical symmetry. Diane Arbus fixed her drama where she found it, in Westchester, New York, a place of large lawns and small families. Ralph Eugene Meatyard masked his actors before he took a photograph of a group in a backyard in Lexington, Kentucky. But both photographs are about family life in this country. If the Arbus picture is an unmasking by the photographer that is terrifying, the Meatyard masking (Meatyard was born in Normal, Illinois), is reassuring in its definition of familial relationships.

Better, perhaps, not to put too definite a text to what might be seen in these pairings, but to again suggest that it is both the accomplishment of the photographer, in his varying roles as interpreter, recorder, or illustrator, as well as the availability of the subject to the photographer's intention, that accounts for the widely varying photographs of personality and type that appear on the following pages. The clearest illustrations of these interactions, and ones in which photographers and subjects are felt most forcefully are on pages 36 and 37, on which Truman Capote and Alfried Krupp and their photographers face each other, and on pages 42 and 43, on which we see an enactment of pathos and a portrait, usually published as a document, by a photographer who saw his subject as herself, however she might otherwise have been taken as a symbol.

[1] Quoted in B. Newhall, *The Daguerreotype in America*, Greenwich, Conn., The New York Graphic Society, revised edition, 1968.

[2] E. W. Curtis, Introduction (Supplementary Vol. I), *The North American Indian*, 20 volumes of text with accompanying supplementary portfolios of photogravure plates, 1907-1930.

Unknown
A Young Black Woman with Silver Jewelry
c. 1860-65
tinted and silvered tintype

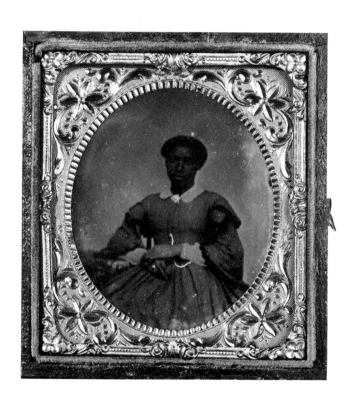

Unknown
Two Young Brothers c. 1845
tinted daguerreotype

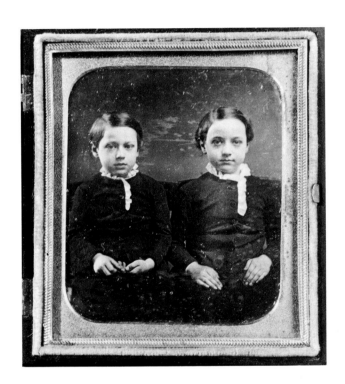

Attributed to **S. A. Holmes,** New York
A Woman and Three Men Posed by Niagara Falls
c. 1858
tinted ambrotype

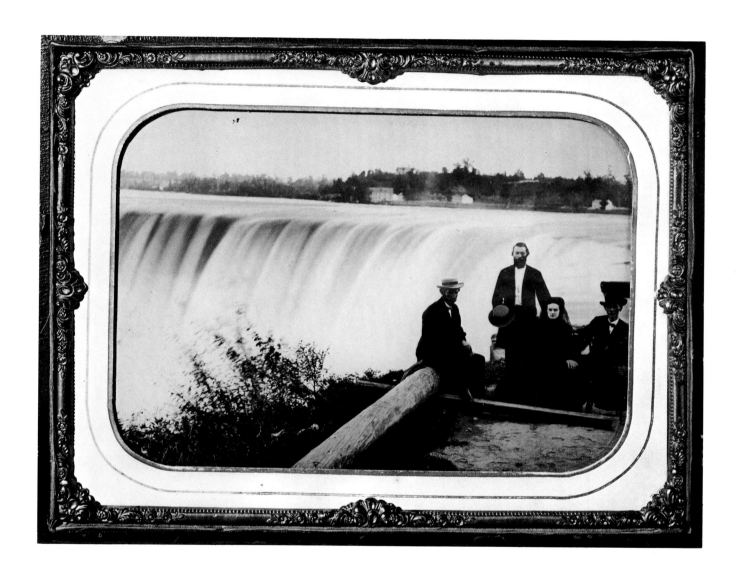

Napoleon Sarony and Benjamin Richardson
The Actor Henry E. Dixey c. 1875
albumen print

T. E. Hinshaw Studio, itinerant
George F. Tilson, M.D. c. 1895
albumen print

T. E. Hinshaw, Photographer.

Elite Studio, San Francisco
Helen Blythe 1881
albumen print

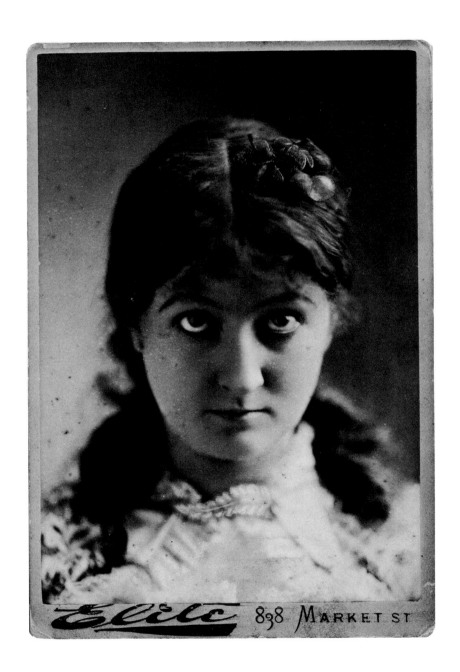

F. A. Rinehart
Hattie Tom, Apache 1899
photogravure

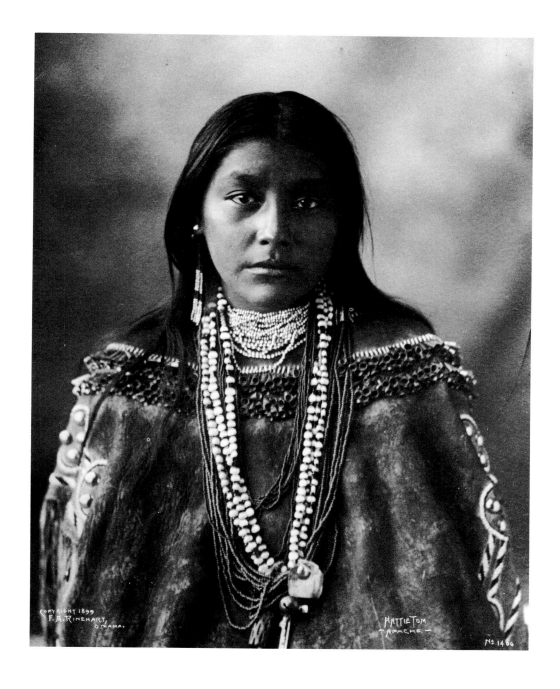

Fox & Symons Studio, Salt Lake City
J. E. Butler, 12th Wd. Meat Market c. 1885
albumen print

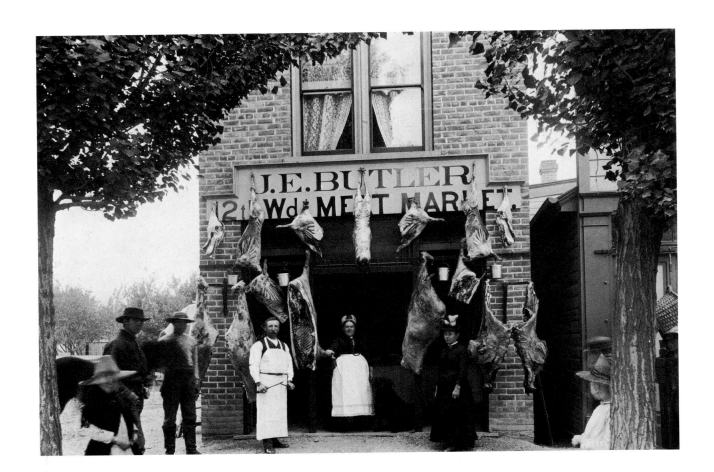

H. S. Klein, Los Angeles
Drama 1896
silver print

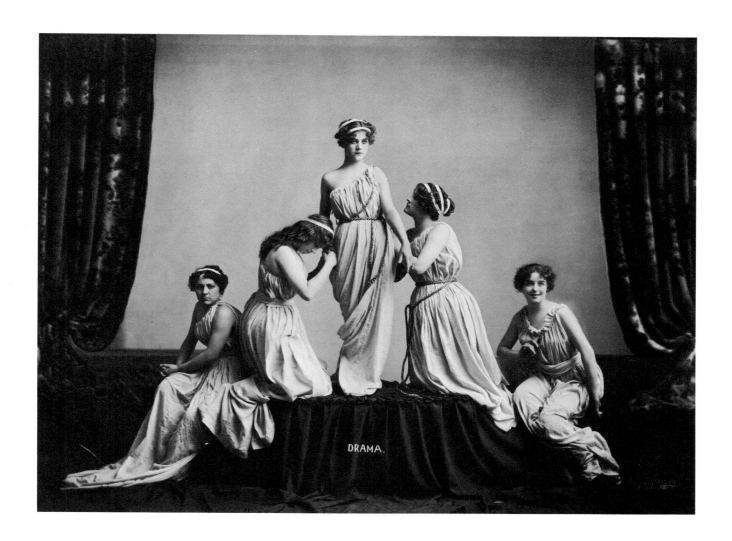

Gertrude Käsebier
Portrait of Miss N. before 1903
photogravure

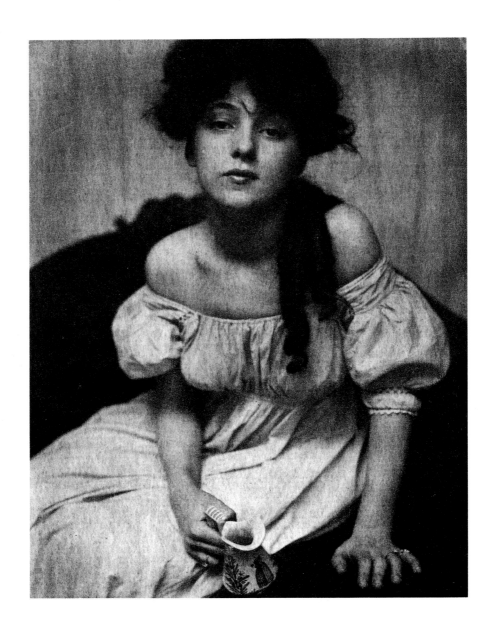

Alfred Stieglitz
Katherine 1905
photogravure

Edward J. Steichen
J. Pierpont Morgan, Esq. 1903
photogravure

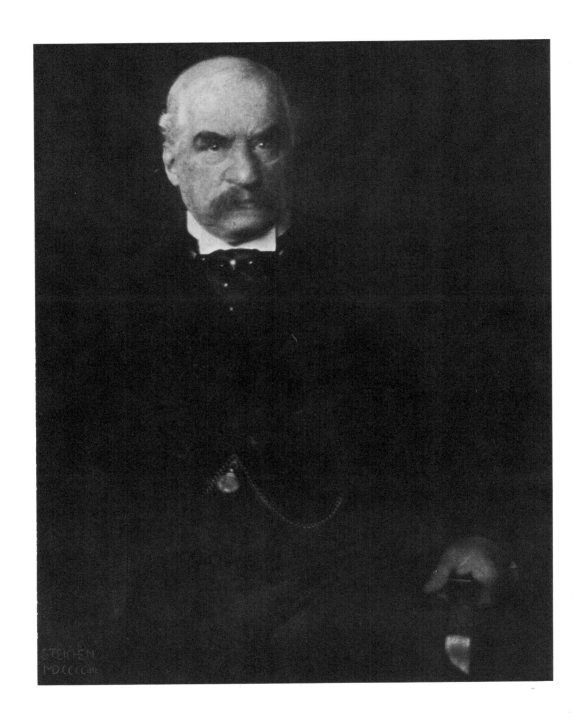

Edward S. Curtis
Nayénezgani—Navaho 1904
photogravure

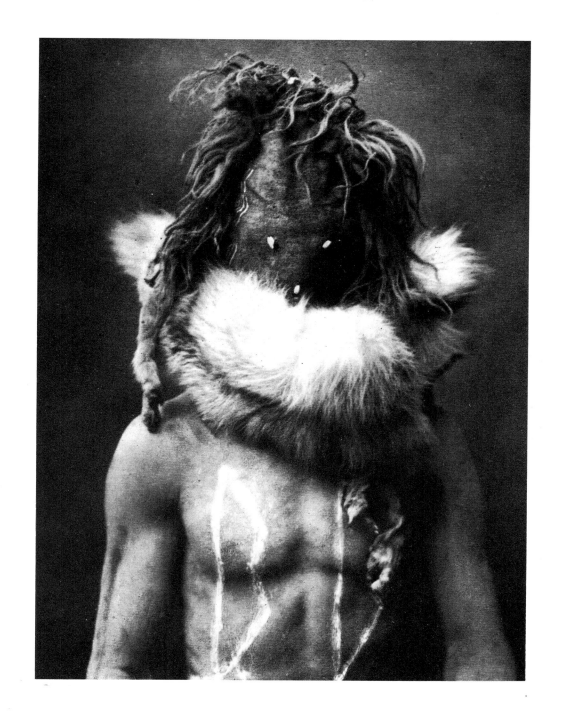

Clarence H. White
Illustration to Clara Morris's "Beneath the Wrinkle"
before 1905
photogravure

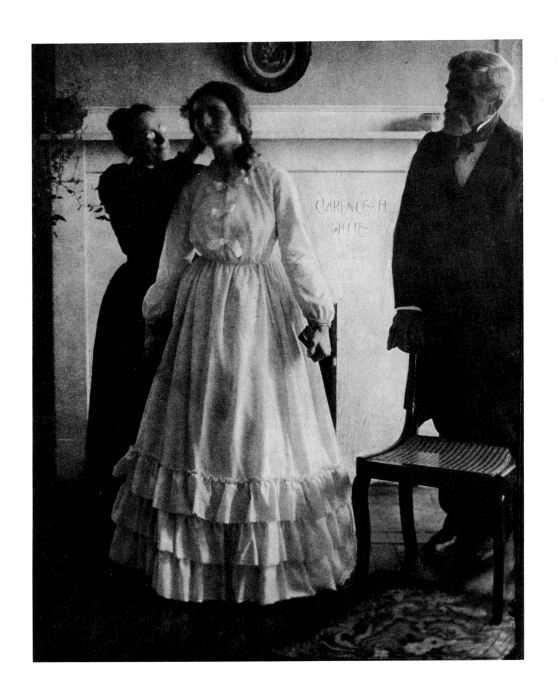

E. J. Bellocq
Portrait, Storyville, New Orleans c. 1912
printing-out paper

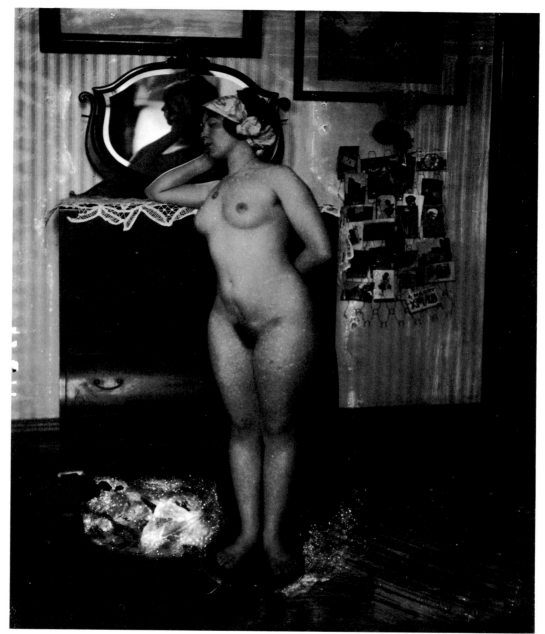

Doris Ulmann
From "Roll, Jordan, Roll' c. 1930-1932
photogravure

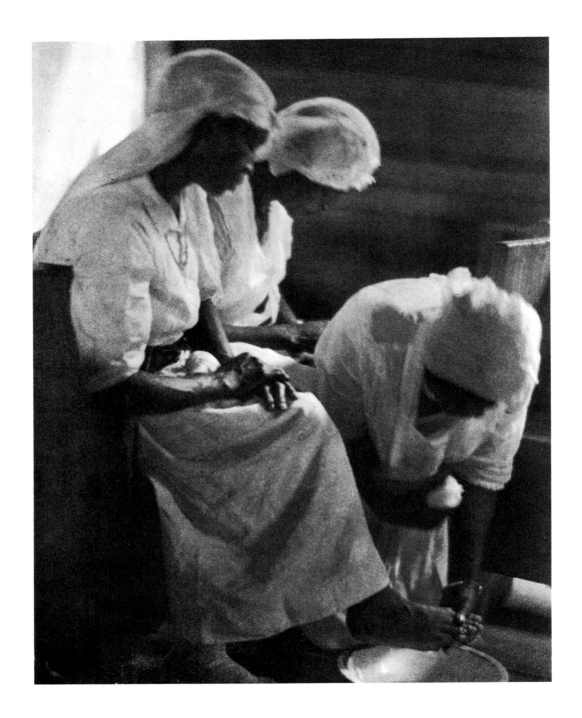

James Van Der Zee
Studio Portrait Group 1927
silver print, toned

Berenice Abbott
James Joyce 1928
silver print

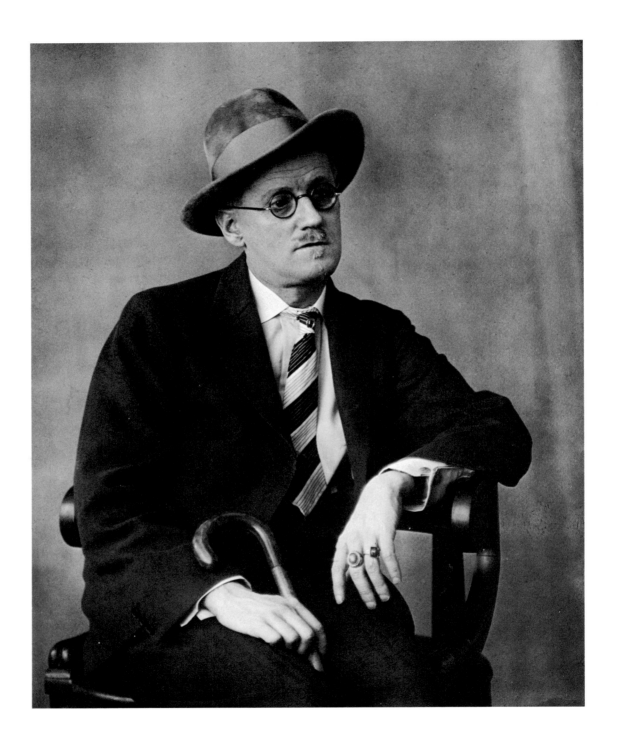

Man Ray
Hands and Rose 1934
silver print, solarized

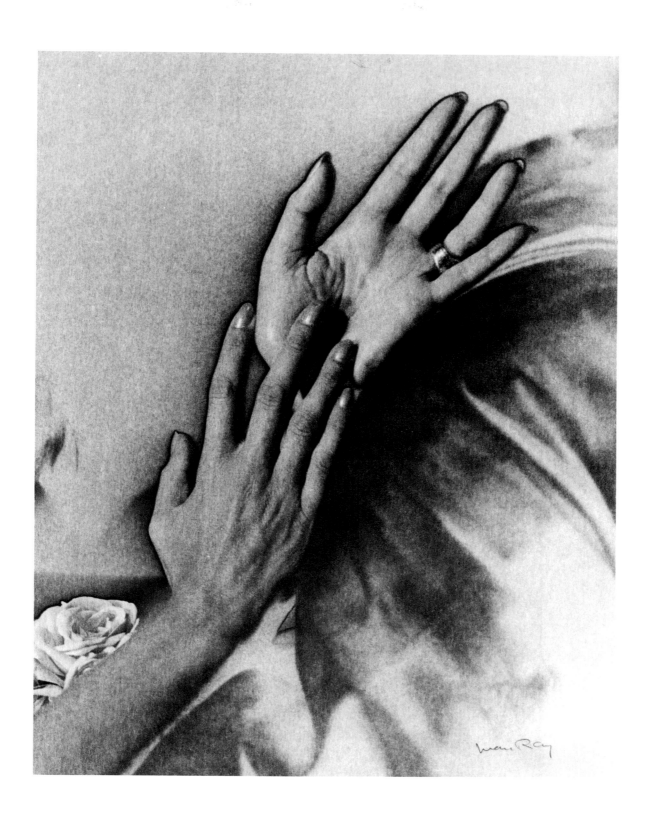

Walker Evans
Alabama Farmer's Wife 1936
silver print

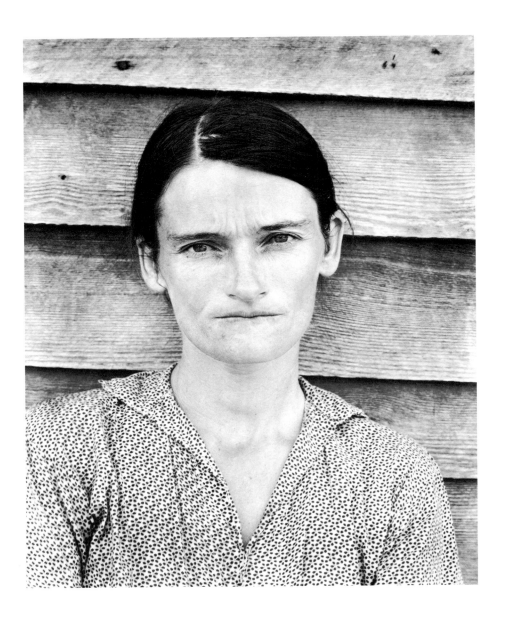

Paul Strand
Young Boy, Goudeville, Charente, France 1951
silver print

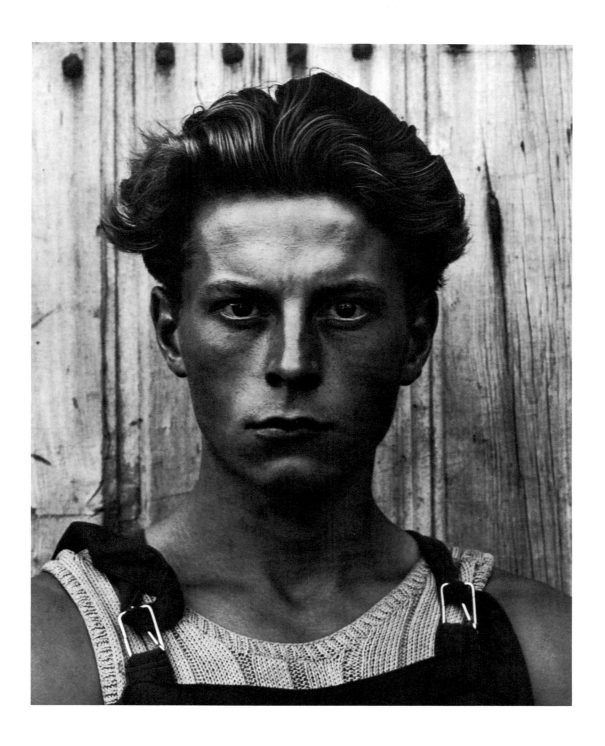

Richard Avedon
Truman Capote 1958
silver print

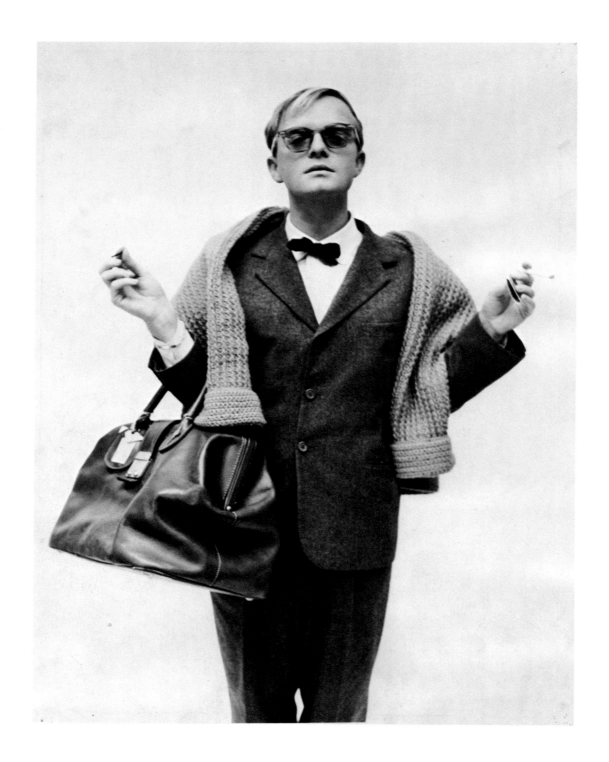

Arnold Newman
Alfried Krupp 1963
silver print

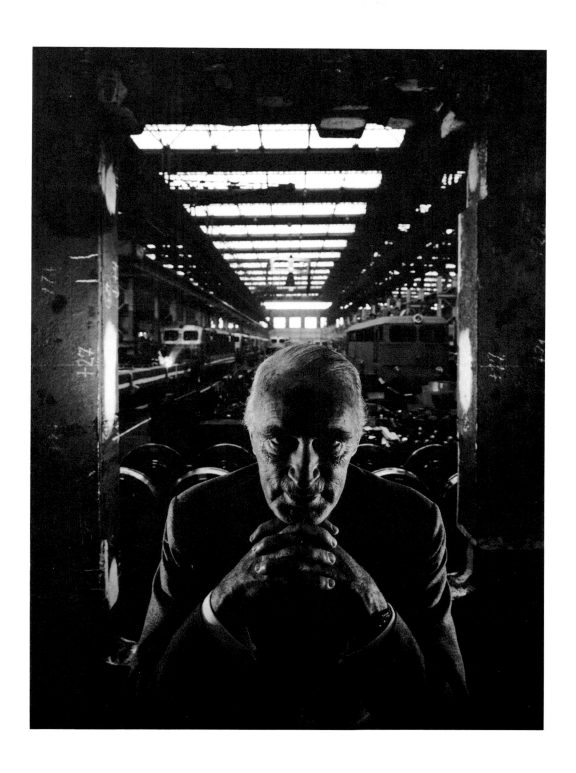

Diane Arbus
A Family on their Lawn One Sunday in
Westchester, N.Y. 1968
silver print

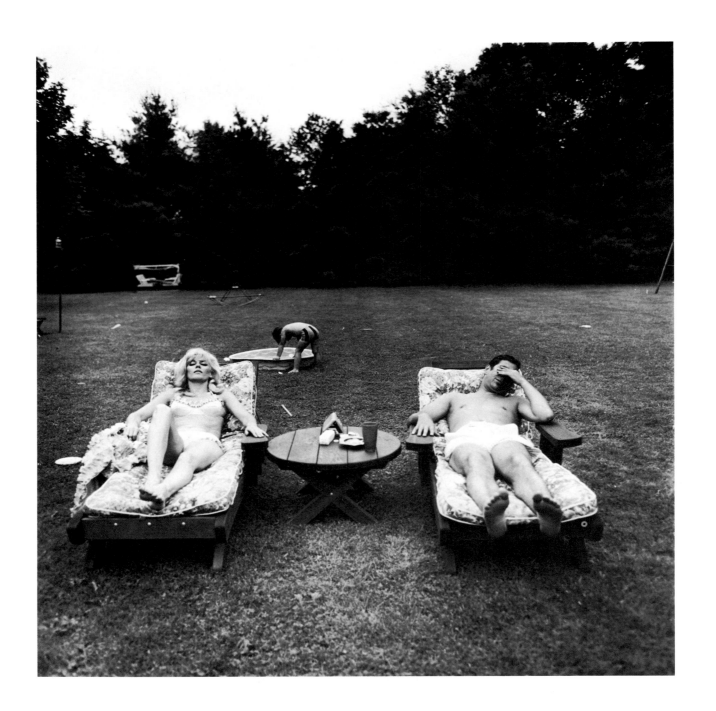

Ralph Eugene Meatyard
Untitled 1964
silver print

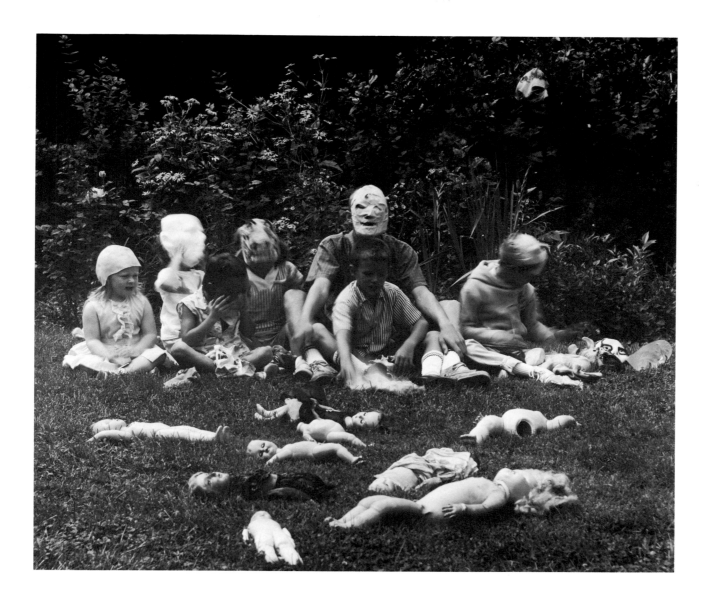

Les Krims
Mom's Snaps 1970
silver print

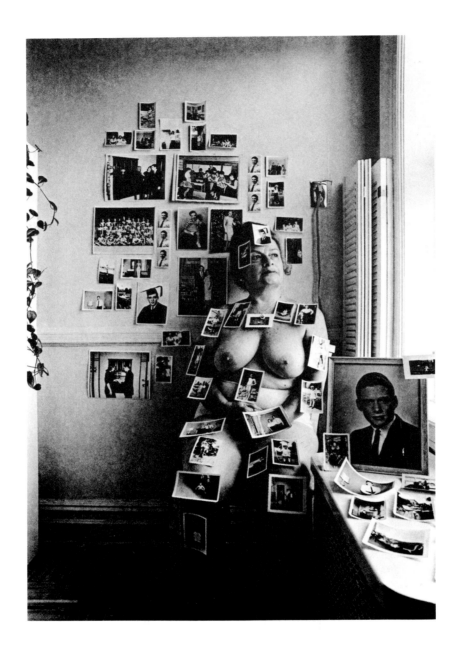

Emmet Gowin
Barry, Dwayne and Turkeys, Gainsville, Md. 1969
silver print

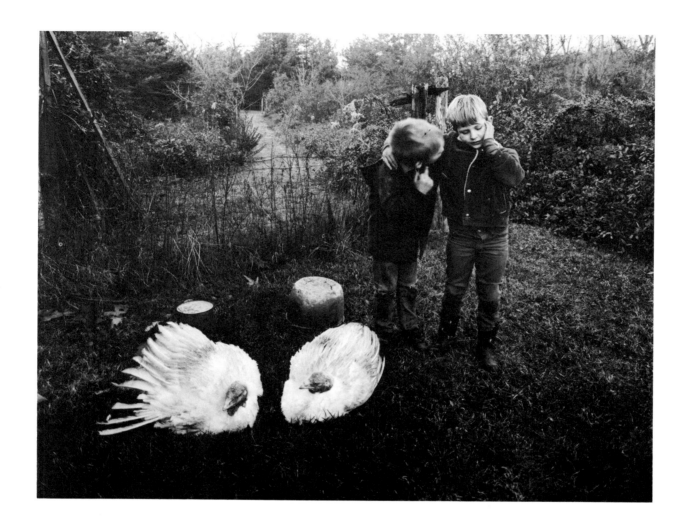

Barbara Morgan
Martha Graham–"Letter to the World" 1940
silver print

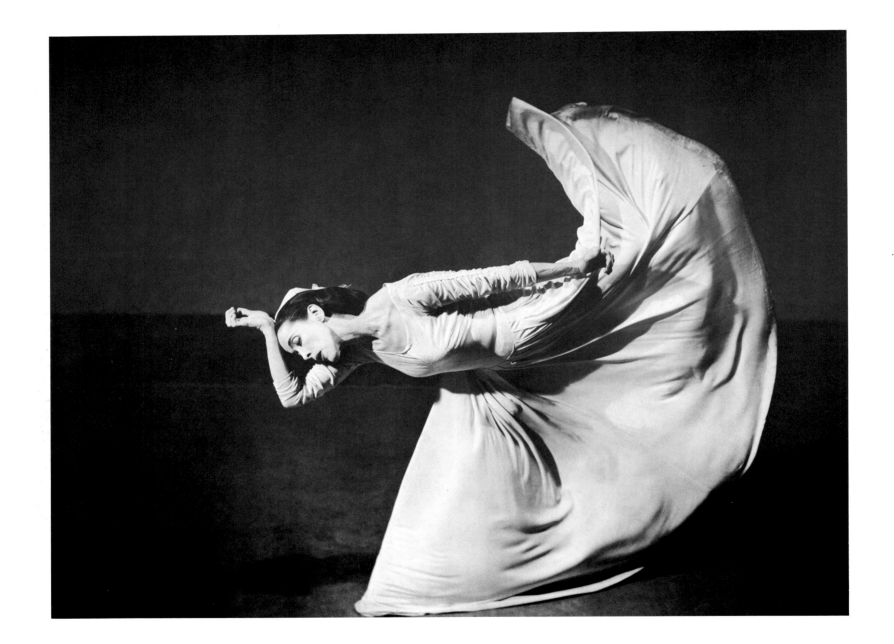

W. Eugene Smith
Tomoko in her Bath 1972
silver print

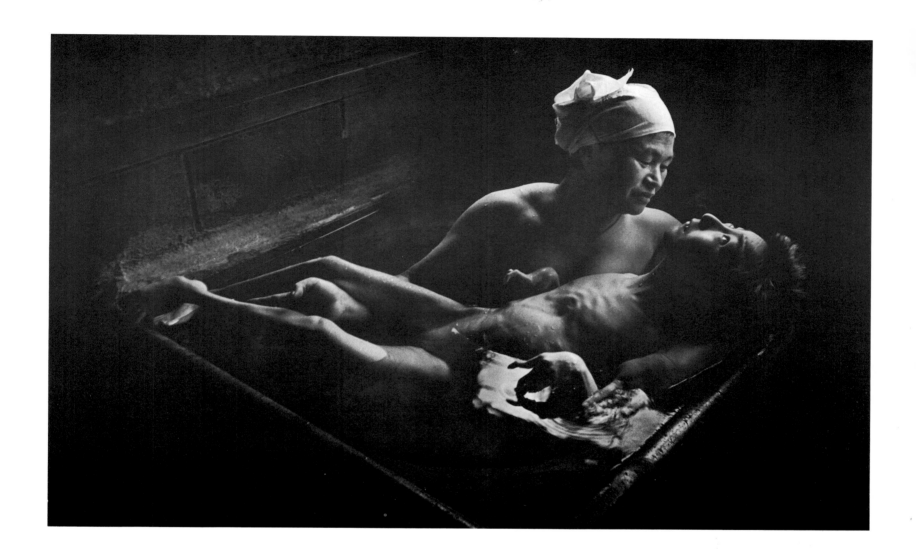

Jerry Uelsmann
Apocalypse II 1967
silver print from several negatives

Duane Michals
René Magritte 1965
silver print

Platt D. Babbitt
Grove Scenery—Winter c. 1860
glass positives for the stereoscope

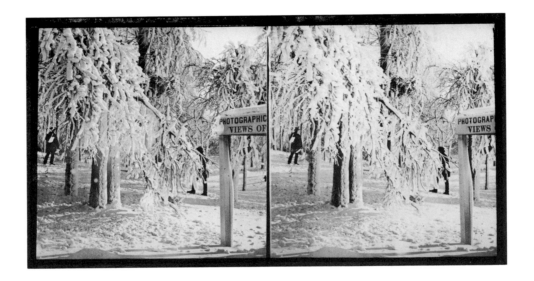

When the daguerreotypist Platt D. Babbitt was granted a monopoly of the view of Niagara Falls from the American side in 1853, he became the proprietor of the right to photograph what was then generally regarded as the most spectacular scenery of this country. Babbitt stayed on at his viewpoint long after the daguerreotype process was abandoned, making ambrotypes, and then prints from wet-collodion plates well into the 1870s. Along the way, he produced stereoscopic views, such as the *Grove Scenery—Winter*, which introduces this selection of photographs from the Monsen Collection.

Views of Niagara Falls, both stereoscopic and in large single prints, were first widely seen in London in 1861. The *Times* of London then remarked that "till the last two or three months the grand scenery of North America with its checkered beauties of cataract and river, lake and mountain, have remained unknown save to those who have extended their travels so far." Of all the views then issued by the London Stereoscopic Company, whose photographer went as far west as the Mississippi, the *Times* found those of Niagara, "the matchless cataract, the fountain of an infant sea," the most spectacular. Several large views of the Falls were issued with the stereoscopic views; they were "wonderful examples of the vividness with which, in skillful hands, photographs may be made to reproduce even the most fleeting grandeur of these tremendous cataracts. Some of these are most beautiful and excellent of their kind—quite beyond mere description to do justice to."[1]

Two notes are sounded in the *Times's* review that continue even now to pertain to the photography of landscape: the photograph as substitute for travel, and the desirability of a spectacular subject. "Little" views were not much craved until there was an audience that felt the quality of the photograph as strongly and as exclusively as it felt the distance and power of the landscape. *River View, Englewood Cliffs, New Jersey*, of about 1870, is better seen by eyes interested in a fine photographic print than by the armchair traveler, who would rather marvel at the views taken of areas closed to comfort, such as those brought back from the Government's Geological & Geographical Surveys of the Western Territories by the survey photographers William Henry Jackson, Timothy O'Sullivan, William Bell and John K. Hillers in the 1870s, or those of the wonderful Yosemite Valley and the surrounding High Sierra made by Carleton E. Watkins (first in 1861, the very year that the photographs of Niagara were impressing the London reporter) and Eadweard Muybridge in 1867 and 1872. In the nineteenth-century, it was the near-impossibility of getting to the view, and once there, the difficulty of

making a successful negative of it that were remarked upon as recommendation of a photographer's work as important as the print that the difficulties, once overcome, had produced. A typical expedition by Watkins, who traveled with his wet-collodion gear, as did all of the landscape photographers from about 1855 to 1880, was later described: "At that time travel to the Yosemite Valley was difficult and the Valley itself accessible only by very crude trails. At least twelve mules were required to pack the outfit of the indomitable photographer. It must be borne in mind that large glass plates [Watkins worked with 17 x 22 inch plates] formed a very important part of his equipment. The tent used in coating and developing these plates was a load for one mule. This young man was required to take five mules in his train carrying camera, tent, etc. around the Valley with him, from point to point. As each picture was made the tent had to be set up, the plates coated and then immediately exposed and at once developed. Photographic processes were slow and also the exposure, which must necessarily be prolonged. . . ."[2] And of Muybridge's Yosemite photographs of 1867, *The Philadelphia Photographer*, the influential American journal of photography, said in its issue for November, 1869, that "To photograph in such a place is not ordinary work. It differs somewhat from spending a few hours with the camera in Fairmont or Central Park," which was putting it mildly.

The documentation and interpretation of heroic landscape was interrupted, not only by civilizing marks made on the land as it became more and more accessible, but by an increasingly pictorial approach to the photography of landscape that was generated to some extent by changes in technical processes—softer papers, faster films, the possibility of enlargement. The Photo-Secessionists, who set the standards of fine photography after the turn of the century, were interested mainly in urban views, and in interpretation of personality or of society. Although Edward Steichen's *Moonlight: The Pond* may have been foreshadowed by Muybridge's often repeated "moonlight" and "reflection" themes, it is an image as shrouded as a dream, and not only a long distance but a world of ideas away from the robust configurations of the Western landscape framed on a large glass plate in the wilderness and brought back like trophies by the intrepid photographers of the nineteenth century.

It was not until 1932, with the formation of the f/.64 group (the name derived from the small aperture used to expose a plate for the greatest detail in depth), that a group of photographers formulated a system of making photographs that would again permit the continuation of landscape

photography in the heroic tradition. The group was influenced by the work of Edward Weston, who had rejected the softness of pictorialism in favor of over-all definition of detail, and who made contact prints from 8 x 10 negatives on shiny paper, rather than enlargements on soft paper, to best achieve his goal. Ansel Adams, one of the members of the founding group, exemplifies this restatement of the tradition in his *Moonrise, Hernandez, New Mexico* of 1944 illustrated here, and in the other of his prints in the collection. Wynn Bullock's *Erosion* and Laura Gilpin's *Bryce Canyon* are part of the continuing influence of Weston's work of the 1920s, not only in the type of view chosen, but in the command of the photographic processes that produces prints in which the view seems to be totally comprehended by the photographer.

It is only comparatively recently, and chiefly under the influence of Minor White, that this excellence of process has been used to convey something of a different, less specific nature. In White's *Bird Lime and Surf, Point Lobos*, 1951, and Emmet Gowin's *Peat Drying, Isle of Skye*, 1972, the landscape is not so much comprehended as it is reinterpreted.

[1] Quoted in *The Photographic Journal*, Royal Photographic Society, London, 15 April 1861, p. 169.

[2] Charles B. Turrill, "An Early California Photographer: C. E. Watkins," *News Notes of California Libraries*, 13, January 1918. Quoted in M. Pauline Grenbeaux, *Carleton E. Watkins*, unpublished master's thesis, Department of Art, University of California, Davis, 1975.

Unknown
River View, Englewood Cliffs, New Jersey c. 1870
albumen print

Unknown
Lookout Mountain, Tenn. c. 1860-1865
albumen print

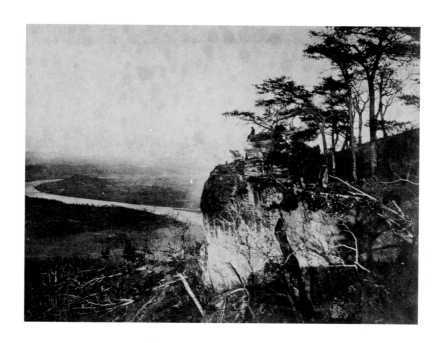

Timothy H. O'Sullivan
Shoshone Falls, Snake River, Idaho 1874
albumen print

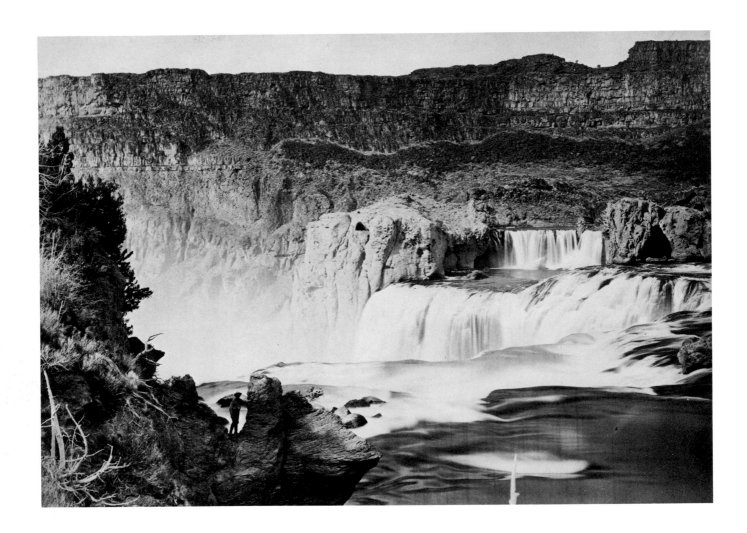

Carleton E. Watkins
Yosemite Valley: Vernal and Nevada Falls from
Glacier Point c. 1861-1863
albumen print

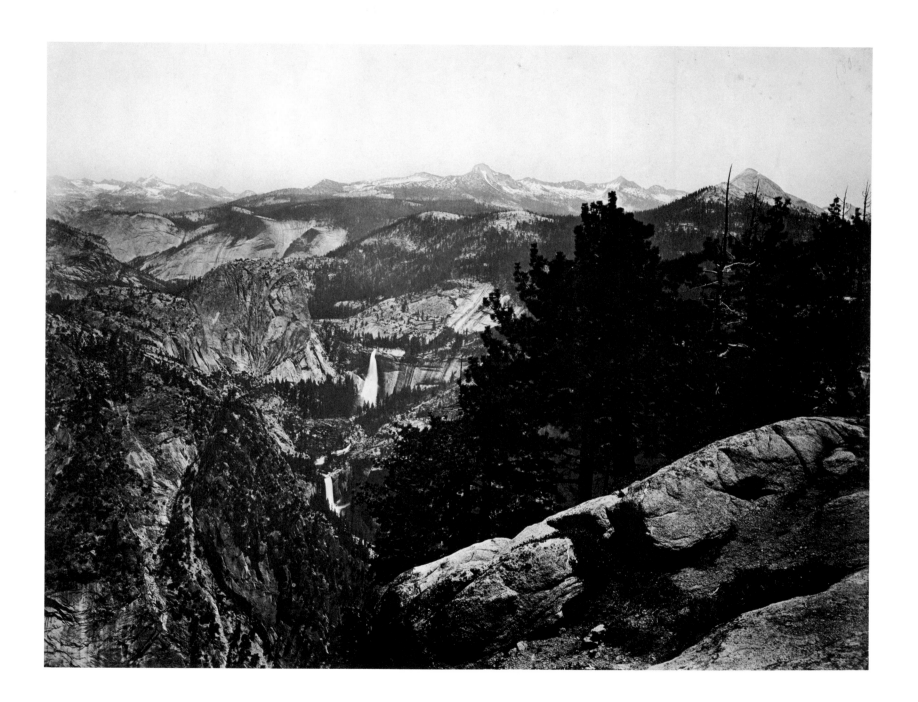

Eadweard J. Muybridge
Cottonwood Bend–Valley of the Yosemite 1872
albumen print

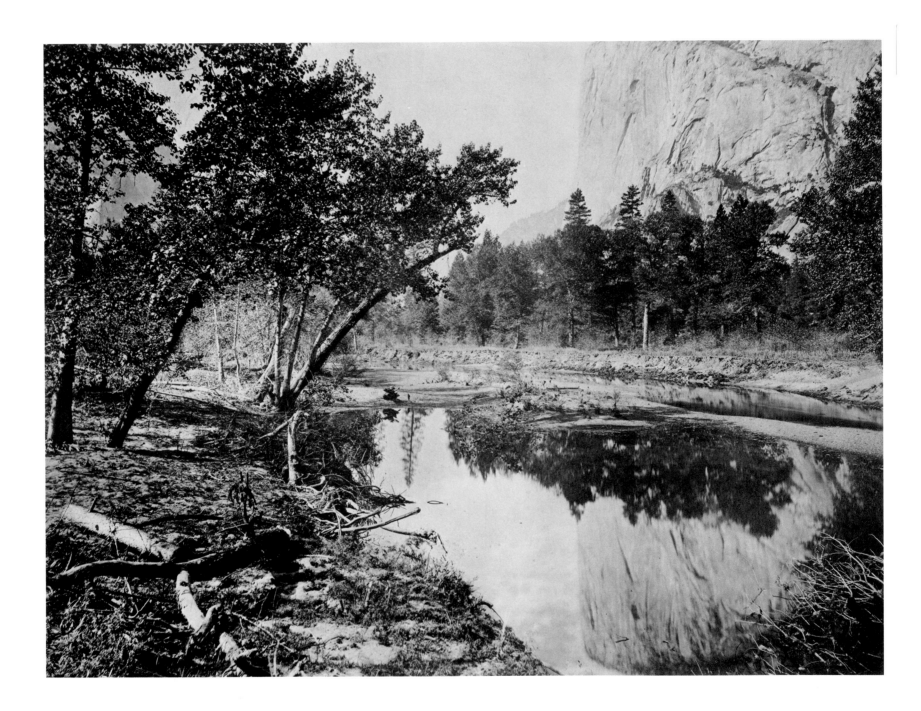

William Bell
*Grand Cañon of the Colorado River, Mouth of
Kanab Wash, Looking West* 1872
albumen print

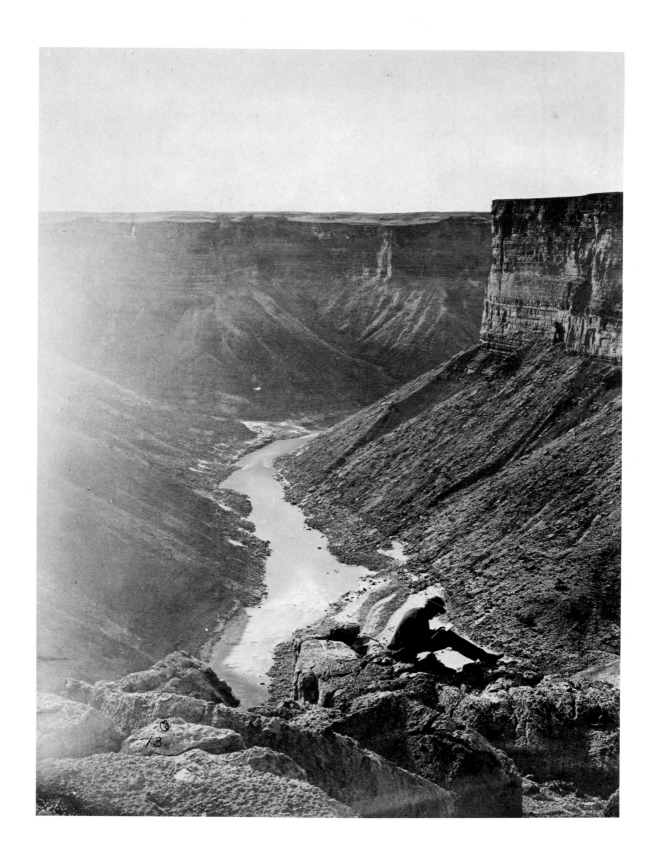

William H. Jackson
Hot Springs, on Gardiner's River, Upper Basin
1871
albumen print

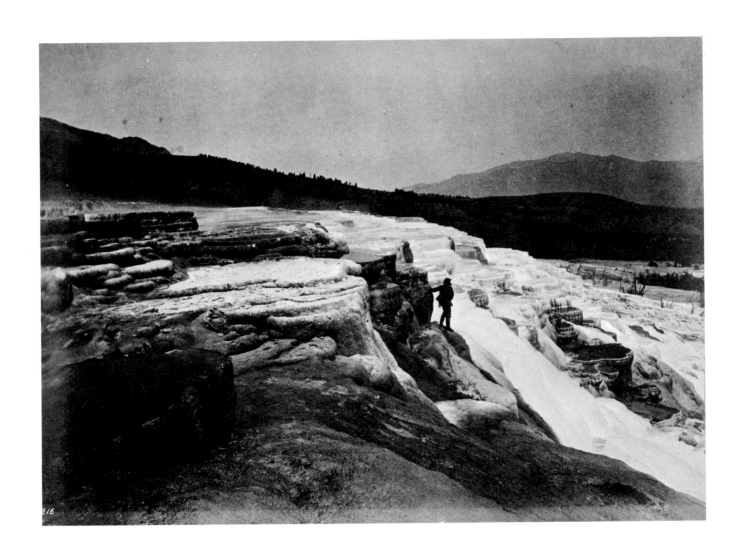

Charles R. Savage or William H. Jackson
Quarrying Granite in Cottonwood Canyon for the
Mormon Tabernacle 1872
albumen print

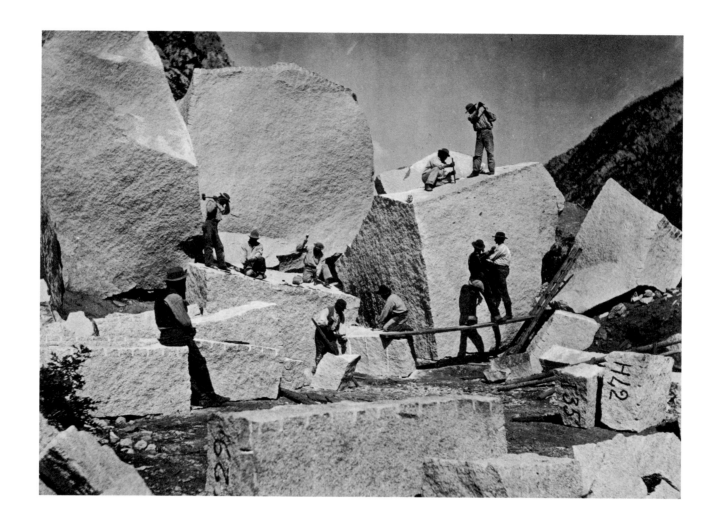

56

Andrew J. Russell
Hanging Rock, Echo City, Utah c. 1868
albumen print

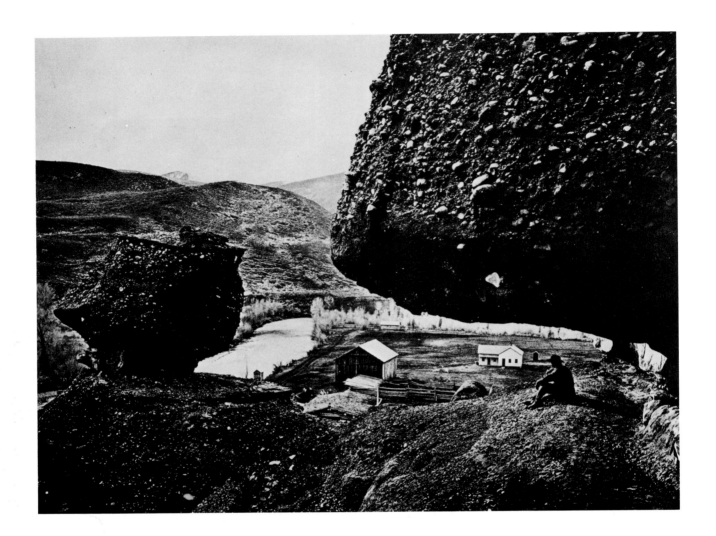

F. Jay Haynes
Liberty Cap and Hotel, Yellowstone National Park c.
1885
albumen print

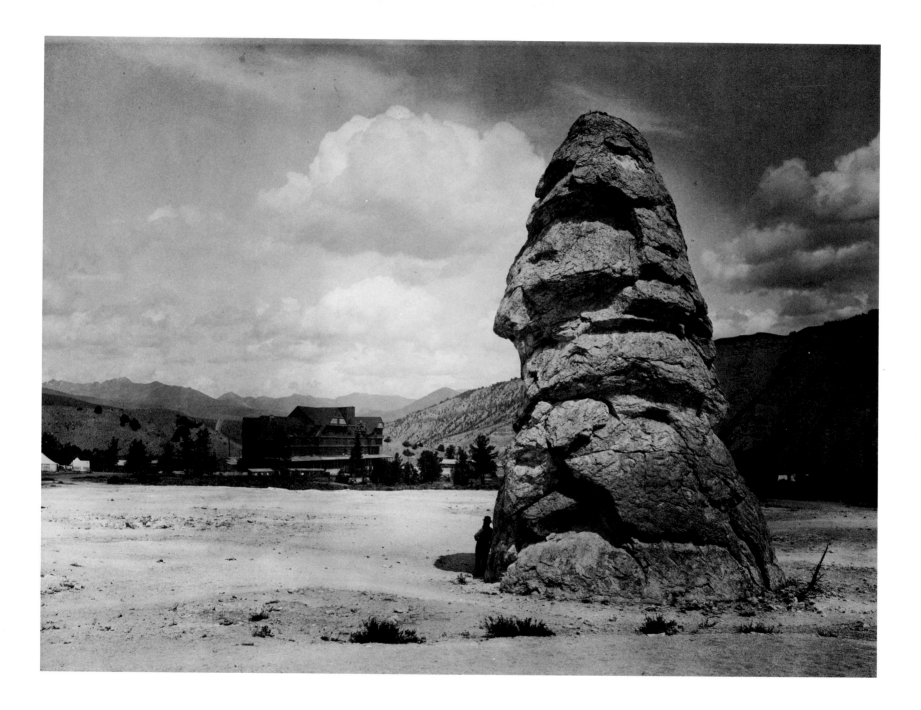

John K. Hillers
Winslow's Cascade on Winslow's Creek, Utah 1875
albumen print

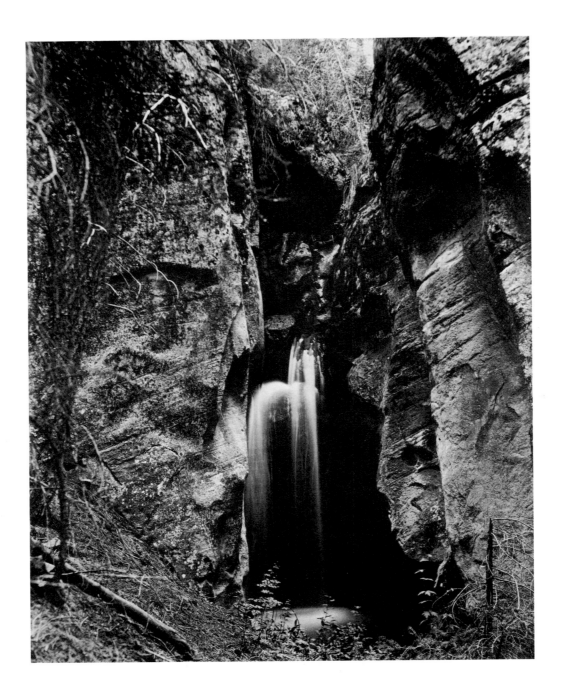

William H. Jackson
Cañon of the Rio Las Animas after 1880
albumen print

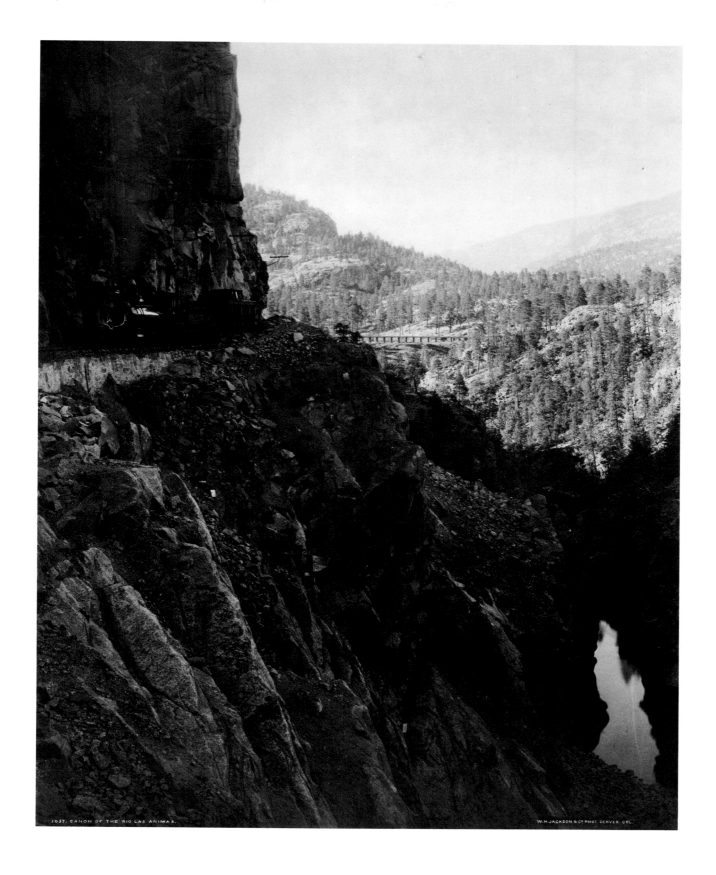

C. H. Nielson
Niagara Falls c. 1880
albumen print

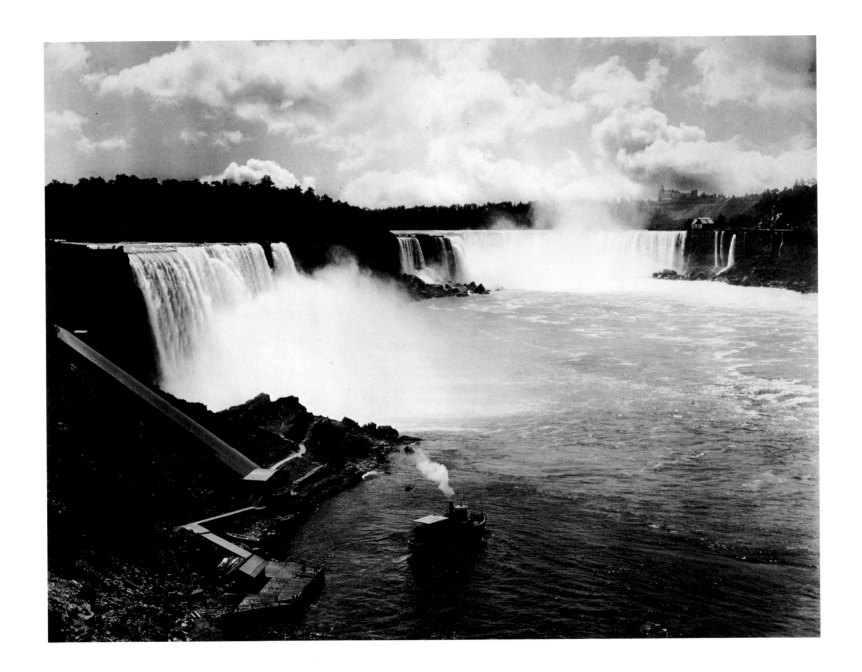

Charles Bierstadt
Ice Bridge, Niagara Falls c. 1867-1870
albumen prints for the stereoscope

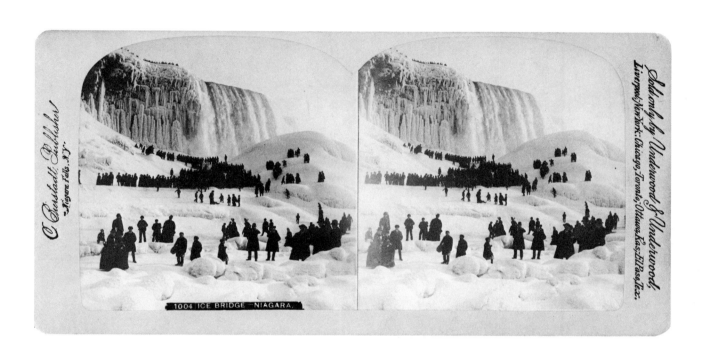

Edward J. Steichen
Moonlight: The Pond 1902
photogravure

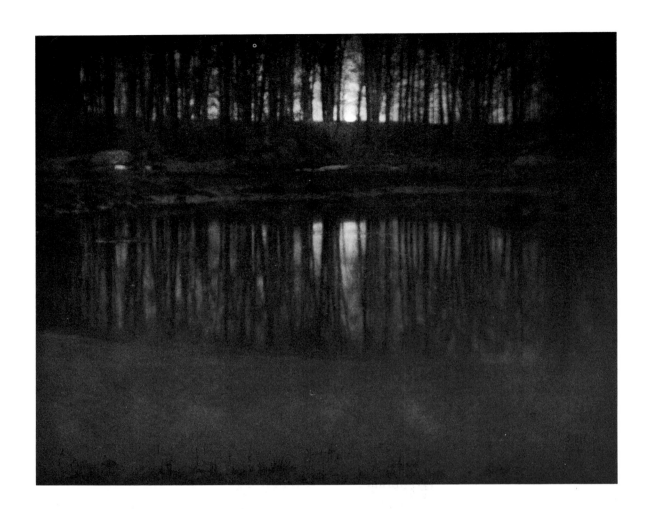

Alfred Stieglitz
A Dirigible 1910
photogravure

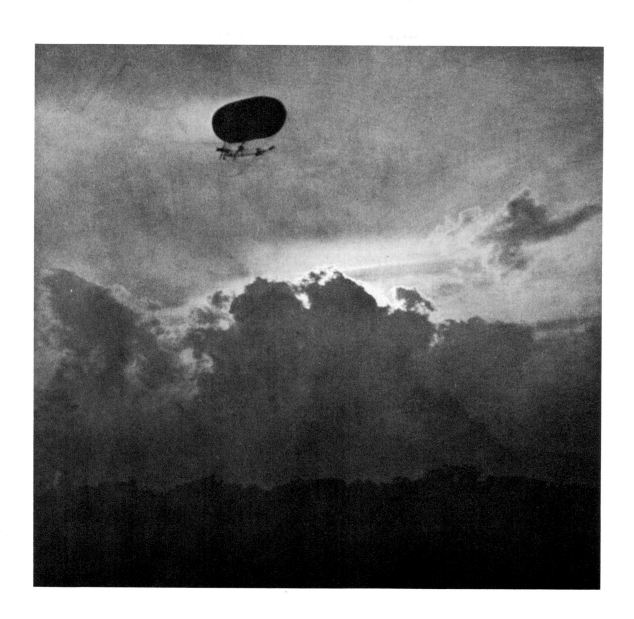

Imogen Cunningham
On Mt. Rainier 1915
platinum print

Edward Weston
Valle de San Juan Teotihuacan, Mexico 1923
platinum print

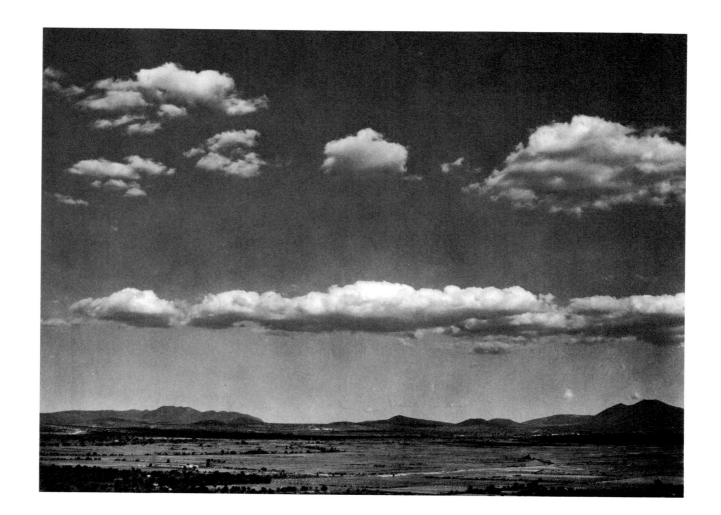

Ansel Adams
Moonrise, Hernandez, New Mexico 1944
silver print

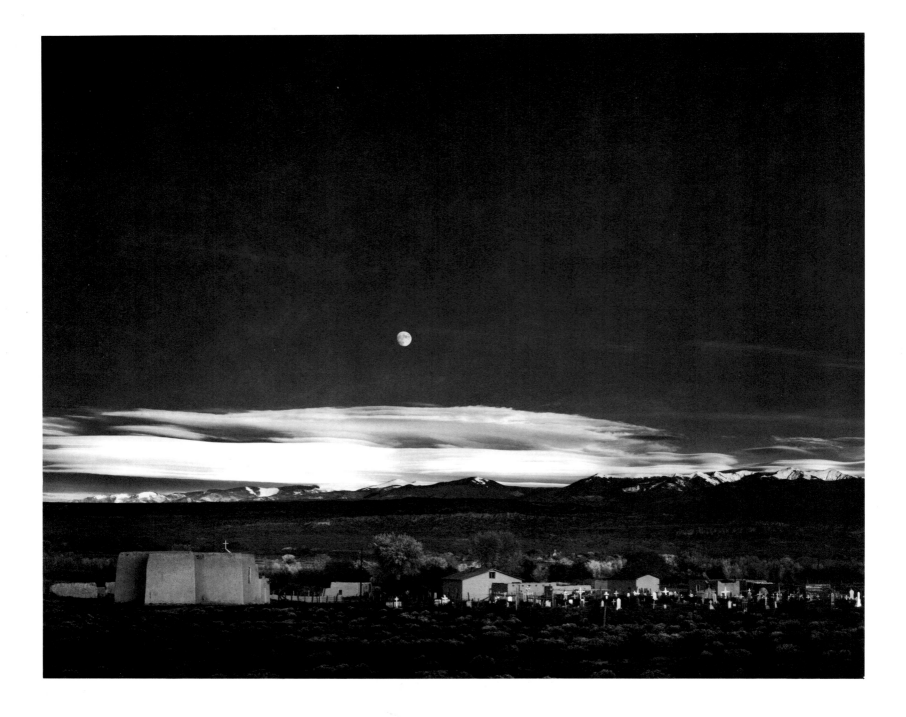

Laura Gilpin
Bryce Canyon No. 2 1930
platinum print

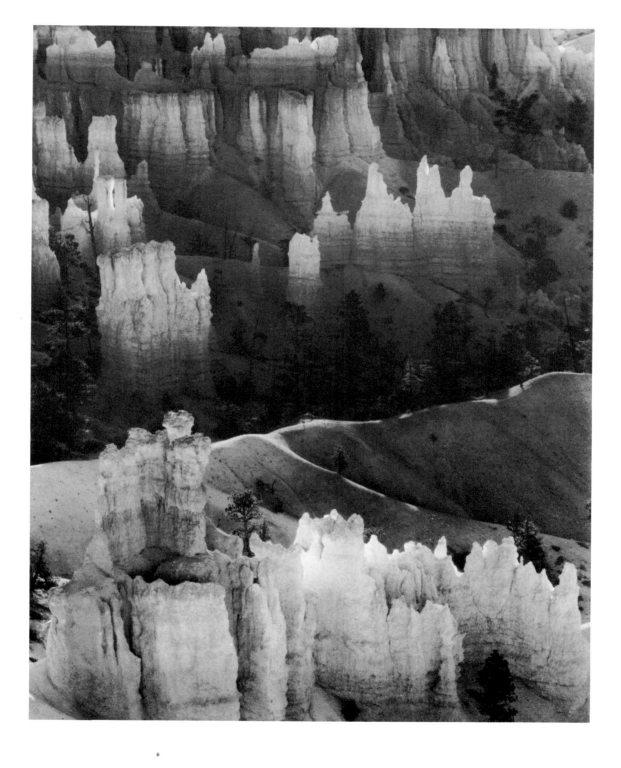

Wynn Bullock
Erosion 1959
silver print

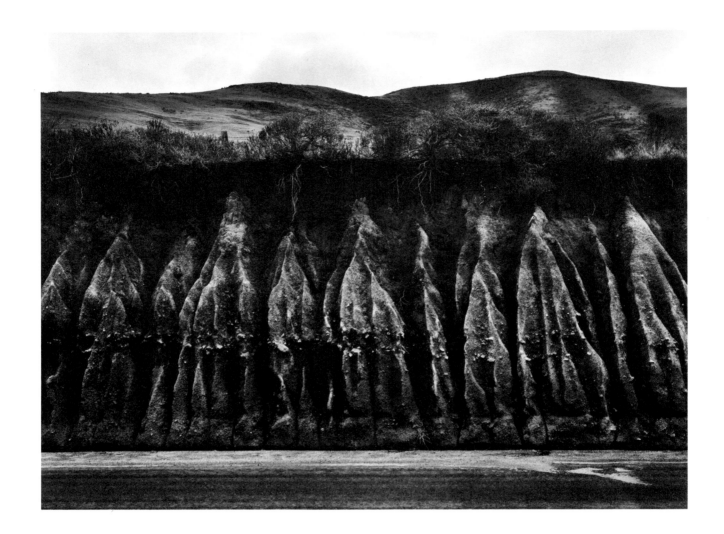

Frank Gohlke
Landscape 1974
silver print

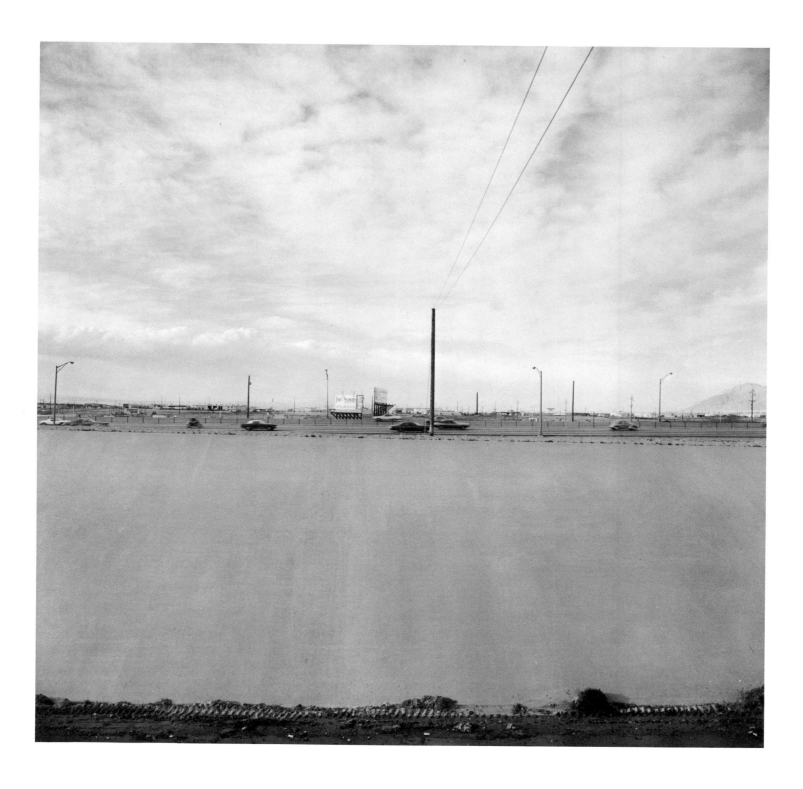

70

Minor White
Bird Lime and Surf, Point Lobos, California 1951
silver print

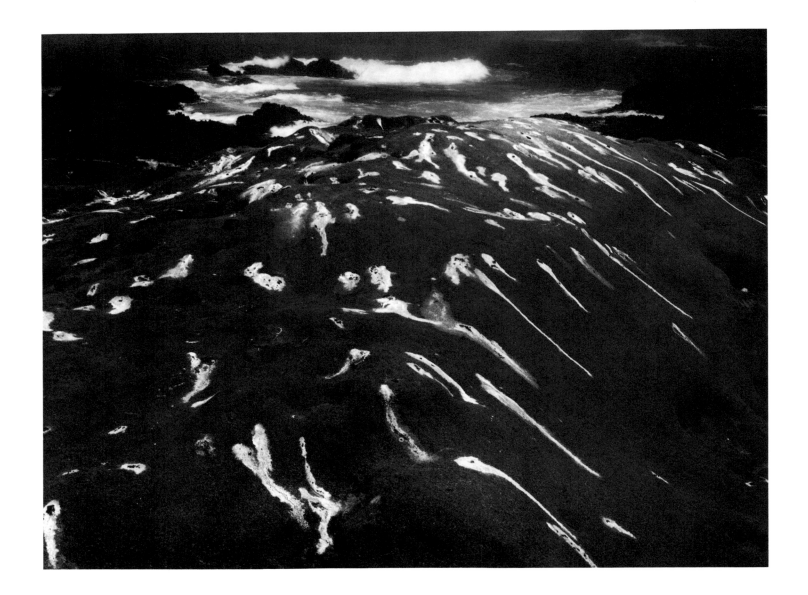

Emmet Gowin
Peat Drying, Isle of Skye 1972
silver print

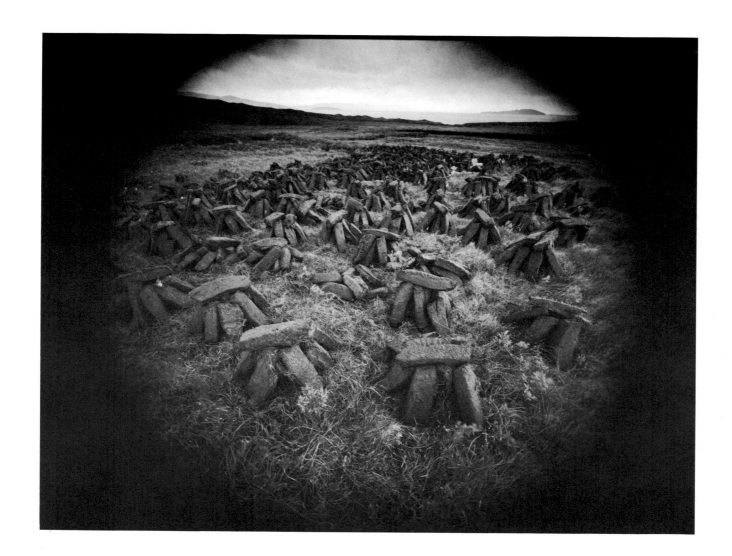

Unknown
View near Springfield, Massachusetts c. 1843
daguerreotype

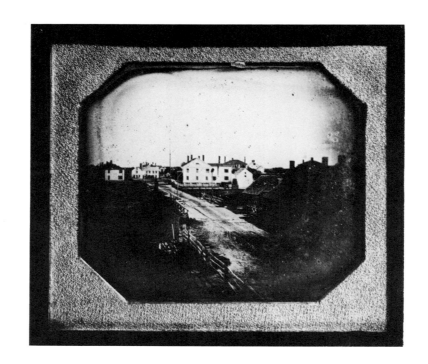

With some poetic justice (at least in regard to the poetry of the vernacular), the first negative made with a camera was of a birdhouse. The French inventor, Nicéphore Niépce, who worked, later, with Louis Jacques Mandé Daguerre (from 1829 until his death in 1833), produced the negative in 1816, using a 1½-inch-square camera fitted with a lens from his solar microscope. Niépce reported his success to his brother: ". . . I saw in the white paper all that part of the birdhouse which is seen from the window and a faint image of the casement. The background of the picture is black and the objects white, that is, lighter than the background."[1] Niépce's first successful positive image, on a pewter plate, was also architectural: a view from his window at Gras. His subject, the buildings, did not move. The sun did, however, during the eight-hour exposure, and made conflicting shadows, to which there was reasonable objection.

Lacock Abbey, the home of the English inventor of the positive-negative process, William Henry Fox Talbot, was recorded successfully on paper in one of Fox Talbot's small cameras in 1835, and among the views taken by Daguerre before the announcement of his process in January 1839 is one of *A Parisian Boulevard*, 1838. After Daguerre's process was known, a witness reported that "everywhere cameras were trained on buildings. Everyone wanted to record the view from his window, and he was lucky who at first trial got a silhouette of roof tops against the sky. He went into ecstasies over chimneys, counted over and over roof tiles and chimney bricks, was astonished to see the very mortar between the bricks"[2]

In this country, there were similar impressions of the realness of photography's representation of the real. The New York *Morning Herald* for September 30, 1839, described "a very curious specimen of the new mode, recently invented by Daguerre in Paris, of taking on copper the exact resemblances of scenes and living objects, through the medium of the sun's rays reflected in a *camera obscura*. The scene embraces a part of St. Paul's church, and the surrounding shrubbery and houses, with a corner of the Astor House, and, for aught we know, Stetson looking out of a window, telling a joke about Davie Crockett. All this is represented on a small piece of copper equal in size to a miniature painting."[3] This comment on D. W. Seager's view, the first successful daguerreotype made in the United States, was run as a news story.

The daguerrean views illustrated on the pages of this section, one of a town, the other of farm buildings, are the simple but well-achieved promises of the comprehensive use to which the daguerreotype would eventually be put in this country: the panoramic view. An eight-panel view of Cincinnati, taken in 1848, is the first evidence of this use. But the genre of panoramic views of cities is especially identified with San Francisco. The tradition was firmly established in the 1850s, when at least eight panoramic daguerrean views, of from two to six panels, were made of the city from two favored vantage points, Nob Hill and Rincon Point. The subject seemed fantastic to those who had not experienced it: a city built on hills and surrounded by a reach of bay, the port for the fabulous fields of gold, and a harbor crowded with ships (526 in June of 1850) because of the rush to get to the gold. What had been, before President Polk's dramatic announcement of the discovery of gold in California, a place barely inhabited, had become, by 1850, a thriving city. Fantastic as it might seem, the city's existence, as mirrored in a daguerrean panorama, could not be disputed. And why not? Because, as the *Alta California* commented on February 1, 1851, in its discussion of a five-panel panorama by S. G. McIntyre (a dentist from Florida): ". . . . it carries with it evidence which God himself gives through the unerring light of the world's great luminary This will tell its own story, and the sun to testify to its truth"[4]

George R. Fardon's seven-panel panorama of San Francisco, in the Monsen Collection, continues the tradition, but in the positive-negative process; it is the earliest known panorama of San Francisco that is not made up of daguerreotype plates, that could be published in several copies from the original negatives. It was taken, probably, in 1856.[5] Eadweard Muybridge's 360 degree panorama, taken in 1877 from a vantage point higher up on Nob Hill, continues and in a sense ends the genre. For there is no doubt that the photographic panorama supplied evidence for the sentiment about the settlement of land and the building of cities that no single view could encompass, and that no hand-made view, for which man, not the sun, was witness, could offer equal verity. Such views reached their most expressive balance when the city became dense enough to be amazing in its intricacy, and yet remained small enough so the shape of the land beneath it could be known. It is hardly possible to think that a photographer of today, interested in using the camera as an expressive medium, would be troubled to take an urban panorama; the amazement at the achievement of urbanization is lost, and so is the significance of making a technically difficult series of views.

Twentieth-century photographers whose views of cities, towns, dwellings and industrial parks appear on the following pages focus on segments of their subject. In this closer focus (Stieglitz's *Snapshot—In the New York Central Yards*, Coburn's

Fifth Avenue from the St. Regis, Strand's *New York from the Viaduct*), we know more the power of the city—what it requires and what it gives. Stieglitz made the life of the city his subject early in his photographic career. According to Robert Doty, "As early in 1892, Stieglitz had begun to make photographs in the streets of New York with a hand camera. He had just returned to America from his many years as a student in Berlin, with its old world charms. He loathed the raw, commercial world of America, but found in the life exposed to him on the streets and avenues of New York a special kind of beauty. Other members of the Photo-Secession followed his example."[6] When Stieglitz published the work of Paul Strand in a double issue of his magazine, *Camera Work*, in June 1917, he called Strand's powerful images of New York streets and buildings "the direct expression of today."

Later photographers of the city present their subject with a different emphasis. Two of Berenice Abbott's prints in this collection are from negatives made between 1935 and 1939 for the document, "Changing New York," under the auspices of the Federal Art Project.[7] In this work, she acted as a conservationist of New York buildings, preserving their images for us so that we can see them as they were before the wrecker's ball flattened them. Rudy Burckhardt's *Flatiron in Summer* (a title that suggests ironic comment, but which is factual), puts a hazy distance between looking at and living in an untenable situation (but also speaks of the millions who do maintain it). Both of these photographers are people acquainted with urban grief.

The coldest eye of all, however, is cast by Lewis Baltz, whose *Pasadena No. 2*, a forecast of his recently published *The New Industrial Parks around Irvine, California*, pictures for us the uninflected structures with which we currently cover the land in the name of industry. But these photographs are not felt as protest; they are, rather, part of a current search for a type of subject that minimizes incident, thus allowing photographic tone itself to abstract an image.

[1]V. Fouqe, *La Verité sur l'invention de la photographie; Nicéphore Niépce*, Paris, 1867, p. 61. Quoted in translation in B. Newhall, *The History of Photography, from 1839 to the present day*, New York, The Museum of Modern Art, 1964, p. 13.

[2]M. A. Gaudin, *Traité practique de photographie*, Paris, 1844, pp. 6-7. Quoted in translation in B. Newhall, *ibid.*, p. 18.

[3]Quoted in R. Taft, *Photography and the American Scene*, New York, Dover, 1964, p. 15.

[4]Quoted, through the courtesy of Beaumont Newhall, in A. Ventura, introduction, "Gold Rush Panoramas, San Francisco—1850-1853," *Sea Letter*, Vol. 2, Nos. 2 and 3, October 1964, San Francisco Maritime Museum, p. 1.

[5]It shows a further development of the understructure of the steeple of Old St. Mary's Church in comparison with the daguerreotype of 1855, of which we know from paper enlargements now in the collection of the Art Institute of Chicago. For a rich discussion of Charles Meryon's use of these very enlargements in producing his etching *San Francisco* of 1856 and for further information on daguerreotype panoramas of San Francisco, see O. J. Rothrock, "The San Francisco of Alfred Pioche and Charles Meryon," *The Princeton University Library Chronicle*, Vol. XXXIV, Autumn 1972, No. 1, pp. 1-25.

[6]R. Doty, *Photo-Secession, Photography as a Fine Art*, Rochester, N.Y., George Eastman House Monograph No. 1, 1960, p. 46.

[7]The photographs were published in 1939 in *Changing New York*, with text by Elizabeth McCausland, New York, E. P. Dutton. *New York in the Thirties*, New York, Dover, 1973, is an unabridged republication of *Changing New York*.

Frederick Langenheim
Home of Washington Irving, Sunnyside,
Irvington, N.Y. 1856
glass positives, tinted

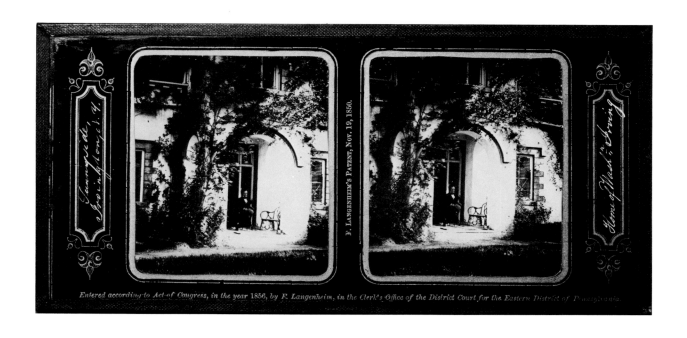

Unknown
New England Farm c. 1843
daguerreotype

John A. Whipple
Hancock House, Boston c. 1854
salt-paper print

Unknown
Merrimack Manufacturing Company c. 1860-1865
albumen print

Eadweard J. Muybridge
San Francisco from the California Street Hill 1877
albumen print (from an eleven-panel panoramic
view)

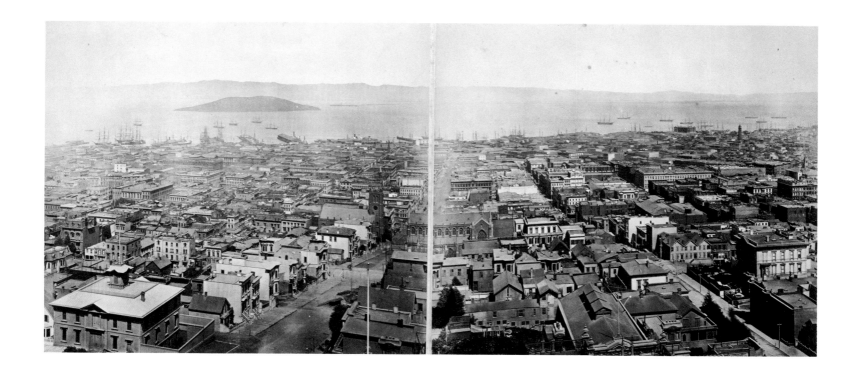

John K. Hillers
Pueblo, New Mexico c. 1873
albumen print

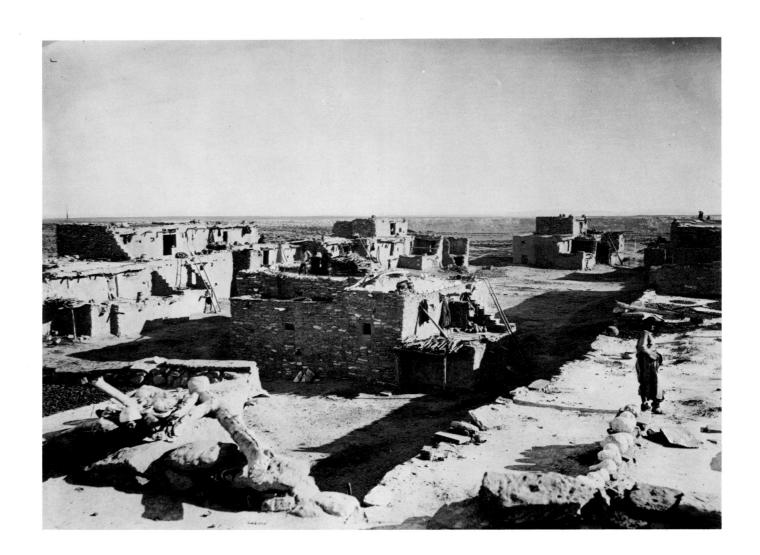

Carleton E. Watkins
The Nevada Mill c. 1880
albumen print

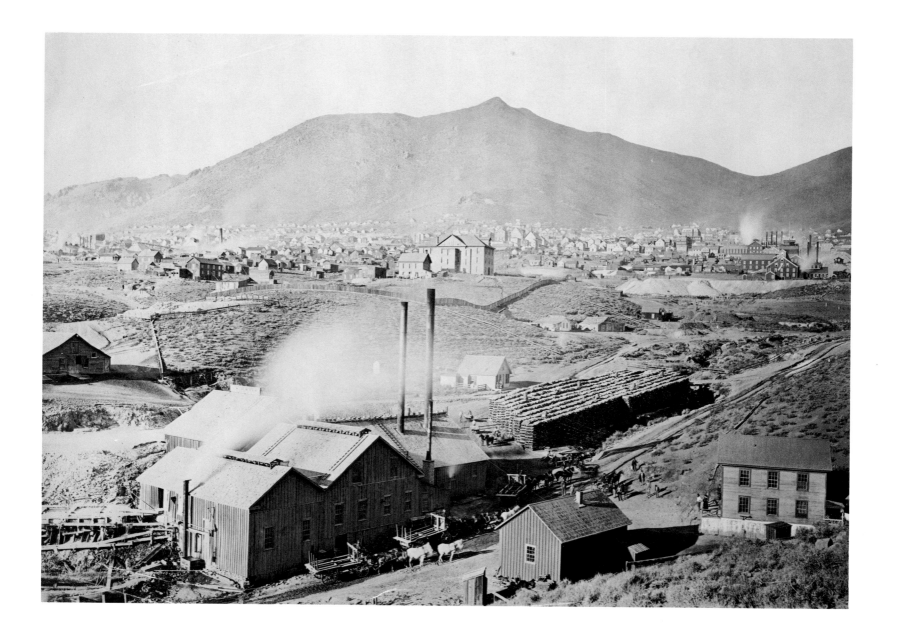

Charles R. Savage
Salt Lake from Prospect Hill c. 1886
albumen print

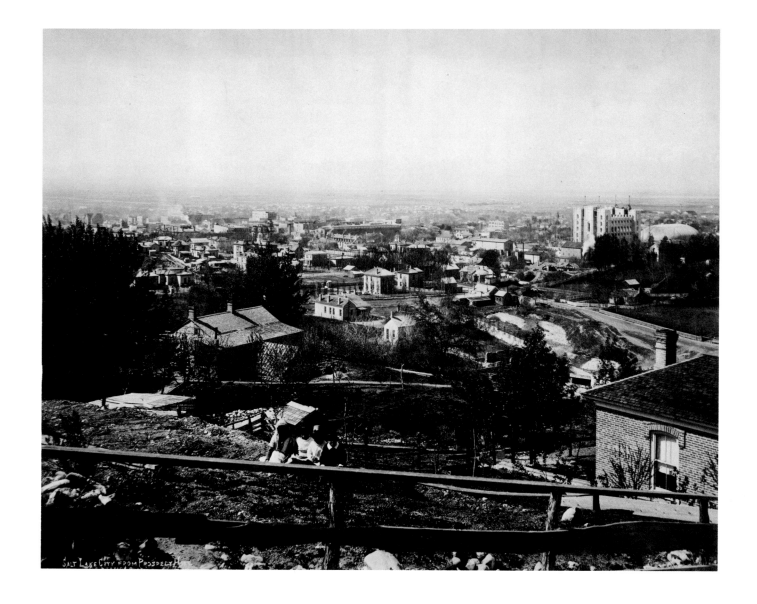

Taber Studio, San Francisco
In Chinatown c. 1880
albumen print

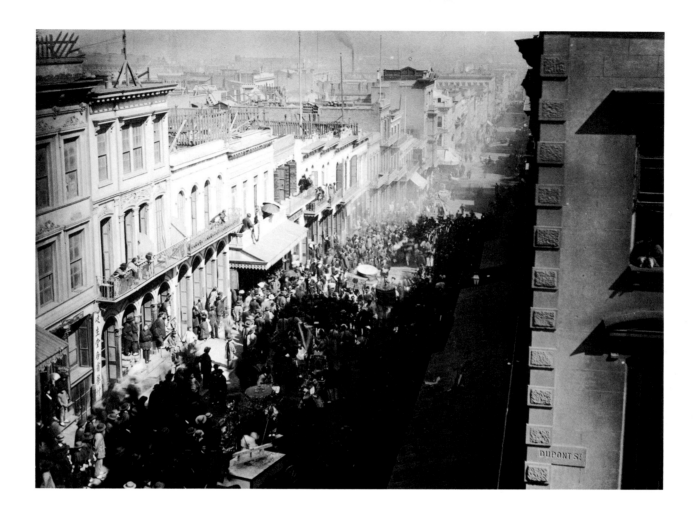

Alfred Stieglitz
Snapshot–In the New York Central Yards
1903
photogravure

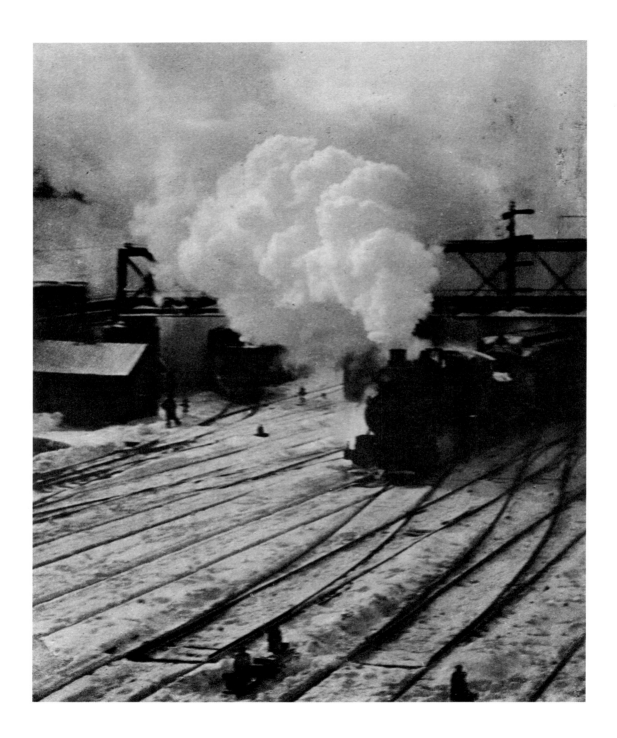

Alvin Langdon Coburn
Fifth Avenue from the St. Regis before 1910
photogravure

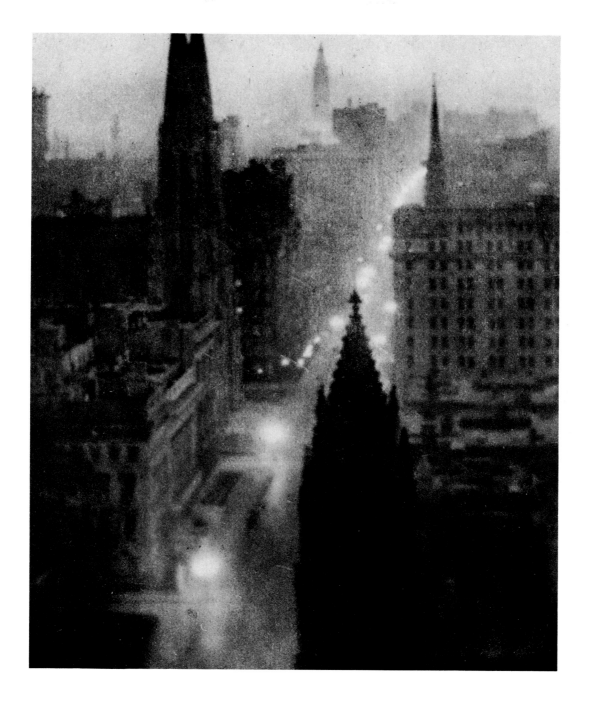

Paul Strand
New York from the Viaduct c. 1915
photogravure

Walker Evans
Main Street, Saratoga Springs 1931
silver print

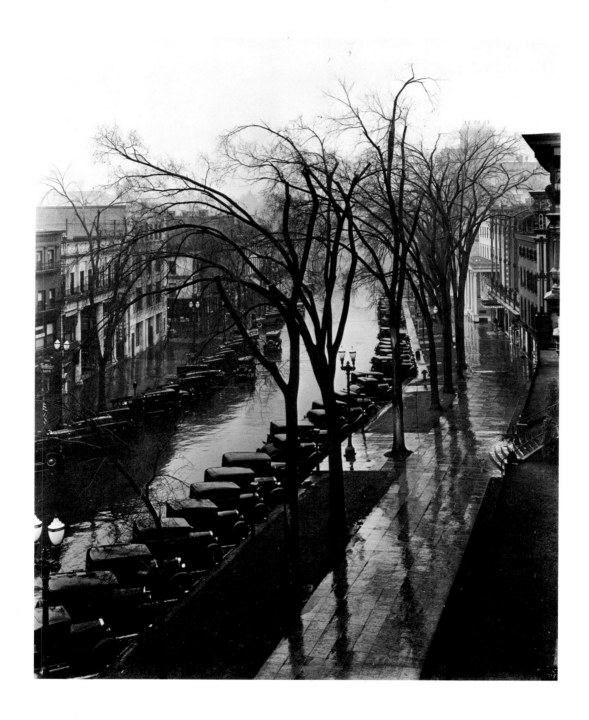

Berenice Abbott
*New York, West Side Looking North from
Upper 30s* c. 1936
silver print

Rudolf Burckhardt
Flatiron in Summer 1948
silver print

Harry Callahan
Facade, Wells Street, Chicago 1949
silver print

Lewis Baltz
Pasadena No. 2 1973
silver print

Unknown
The Dead Man c. 1845
daguerreotype

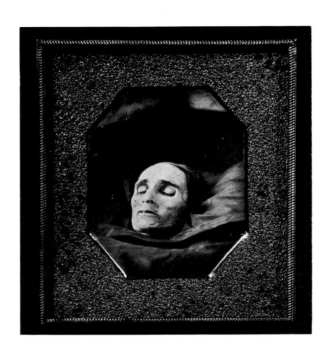

All photographs in which the subject is recognizable document the subject. Here, however, the photograph as document signifies the representation of moments especially crucial, even terrible, in their effect. Here are excluded, for instance, such photographs as the "Documents for Artists" that Eugene Atget advertised, photographs of the streets and buildings of Paris seen in the clear morning light. The documentary photographs illustrated on the following pages have very little movement in them. Many of them were taken with a specific social purpose, to record an event, to call attention to desperate human situations, to change the situations. Most of the subjects were aware of the presence of the photographer. But we do not feel this awareness; the photographer is effaced—that is part of the art of documentary photography.

Most, but not all, of these documentary photographs need words to complete them. Certainly not *The Dead Man*, an example in daguerreotype of a Victorian tradition of making portraits of the dead—a sort of life-ring thrown into the sea of mortality, a pledge of last remembrance. The man's name does not even appear on the mount of the photograph, which we recognize, ironically, to be of the sort called *carte-de-visite*. And the last photograph in the selection, Weegee's down-and-out drunk, carries its message in the image: better to "Drink Coca-Cola."

But many of the photographs were originally accompanied by words. Alexander Gardner, who compiled a *Photographic Sketchbook of the Civil War*, published in 1866, after the war's end, interleaved the photographs with pages of text that described the subjects and also defined attitudes toward them. Of the Wood and Gibson *Inspection of Troops*, the text notes that "Such pictures carry one into the very life of the camp, and are particularly interesting now that that life has almost passed away." But more arresting is the significance of the text that accompanies *The Harvest of Death*, taken by Timothy O'Sullivan, one of Matthew Brady's field photographers, at Gettysburg in July 1863: "Such a picture conveys a useful moral: It shows the blank horror and reality of war, in opposition to its pagentry. Here are the dreadful details: Let them aid in preventing such another calamity falling upon the nation." Brady is said to have had, at the height of his operations, a staff of twenty men working in the field. "I had men in all parts of the army," he said, "like a rich newspaper."[1]

Brady's comparison of his staff's coverage of the war to a newspaper is apt. Would we know the meaning of Dorothea Lange's *Migrant Mother, Nipomo, California* of 1936 quite so exactly without the following written account of the making of the photograph?: "I saw and approached the hungry and desperate mother, as if drawn by a magnet. I do not remember how I explained my presence or my camera to her, but I do remember she asked me no questions. I made five exposures, working closer and closer from the same direction. I did not ask her name or her history. She told me her age, that she was 32. She said that they had been living on frozen vegetables from the surrounding fields, and birds that her children had killed. She had just sold the tires from her car to buy food. There she sat in that lean-to tent with her children huddled around her, and she thought that my pictures might help her, and so she helped me."[2]

Like the photograph itself, the writing is factual and unadorned. It fills out the photograph. Without the written account, we might think that we are looking at an image of a woman watching a particular and distressing event. With the writing, we know that "the dreadful details" of her life combine to be the event.

This particular photograph is one of the most memorable of the some 270,000 made between 1935 and 1943 by a group of photographers who worked in the Historical Section of the Farm Security Administration, a branch of the Department of Agriculture. The project was initiated by President Roosevelt's Assistant Secretary of Agriculture, Rexford Guy Tugwell, a professor of Economics at Columbia University. It was administered by Roy Stryker, an instructor of economics at Columbia who had used photographs in his classes to corroborate, by their witness, the statistical reports that were customarily used as the only source of information on agricultural conditions in this country. The first photographer to join the group was Walker Evans; the staff included, at various times, Carl Mydans, Ben Shahn, Theo Jung, Dorothea Lange, Arthur Rothstein, Russell Lee, Jack Delano, Marion Post, John Collier, Jr., John Vachon and Gordon Parks. (Of them, six are represented by one or more prints in the collection.) The goal, according to Stryker, "was to write the history of the Farm Security Administration. We didn't collect many documents. We collected pictures."[3]

Every original FSA print carries, in handwriting, a title descriptive enough to exactly identify the subject, the time, and the place; without this record, we would but half understand the photographs. Our reading of the image alone would be incomplete and often inaccurate, and would thus nullify the value of the photograph as a document.

In this regard, it is worth mentioning that photographers are often extremely careful writers. It is especially true that prose and documentary photography particularly suit each other. But even before there was such a name for a type of photography that we now call documentary, we find an affinity with words in photographers, who are people who conceive and seize, in a sense, a picture more instantaneously than do painters. In the case of bona-fide documents, the images called up in the words and in the picture are mutually reenforcing.

Although Lewis Hine, whose photographs for the National Child Labor Committee (taken between 1908 and 1921) helped to change the labor laws in regard to children in this country, said "If I could tell the story in words, I wouldn't have to lug a camera,"[4] he was careful to note the circumstance of the taking of a photograph on the back of his print. The typed inscription on the back of his *Workers in a Pa. Coal Breaker, Jan. 1911*, in the Monsen Collection, is apposite in intensity to the photographic image: "Dust so thick it obscured the view much of the time. The boys bend over the constant streams of broken coals, picking out slate. A boss . . . stands over them, prodding or kicking the boys into obedience."

Could we know that from the photograph? Only half. In documents there should be no room for doubt.

[1] R. Taft, *op. cit.*, p. 229.

[2] R. E. Stryker and N. Wood, *In This Proud Land, America 1935-1943 as Seen in the FSA Photographs*, Greenwich, Conn., The New York Graphic Society, 1973, p. 19.

[3] R. Stryker and N. Wood, *ibid.*, p. 12. For some reason, the photographer Theo Jung is omitted from the list of staff photographers given in this book.

[4] Quoted in *Documentary Photography*, Time-Life Books, New York, Time Inc., 1972, p. 56.

Wood and Gibson
Inspection of the Troops at Cumberland Landing,
Pamunkey, Virginia May 1862
albumen print

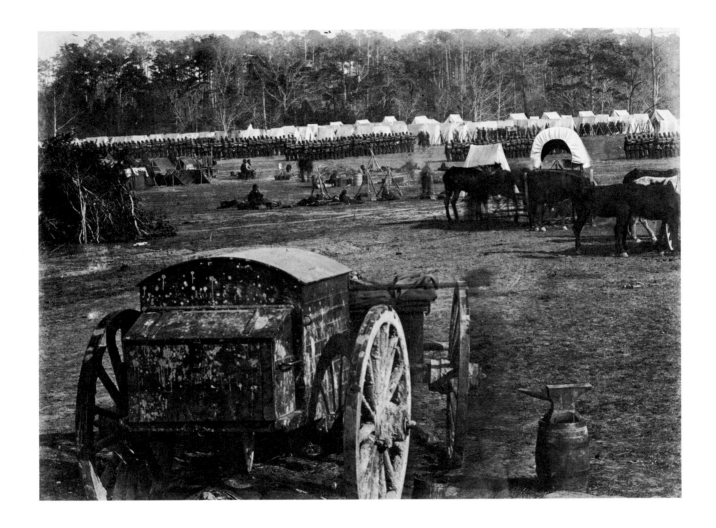

Timothy H. O'Sullivan
A Harvest of Death Gettysburg, July 1863
albumen print

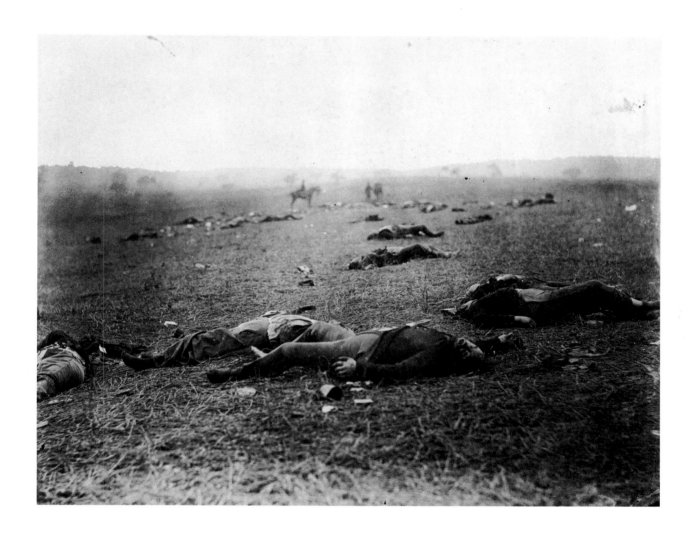

James Wallace Black Studio
Winthrop Square, Boston, after the great fire of
November 9th and 10th, 1872
albumen print

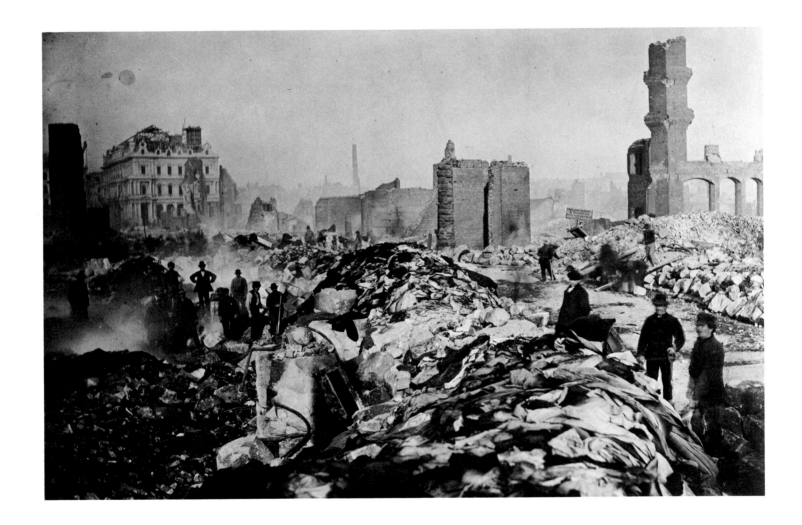

Unknown
*San Francisco after the earthquake of
April 18, 1906*
silver print, toned

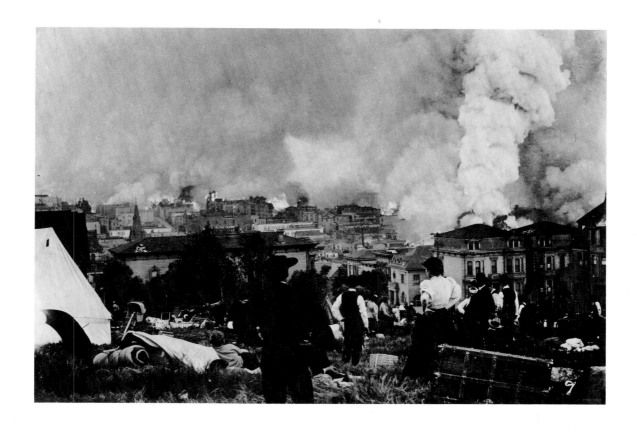

Alfred Stieglitz
The Steerage 1907
photogravure

Russell Lee
*Unemployed Workers in front of shack with Xmas
Tree, E. 12th St., N.Y.C.* 1936
Farm Security Administration print, silver

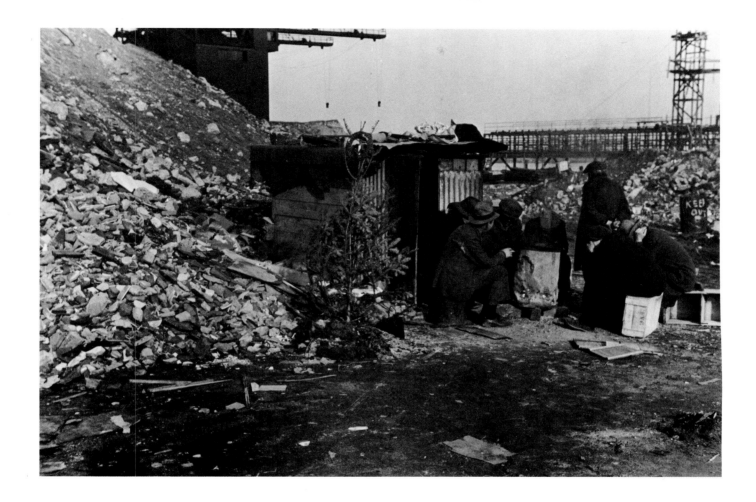

100

Dorothea Lange
Waiting for Relief Checks at Calipatrin, California
March 1937
Farm Security Administration print, silver

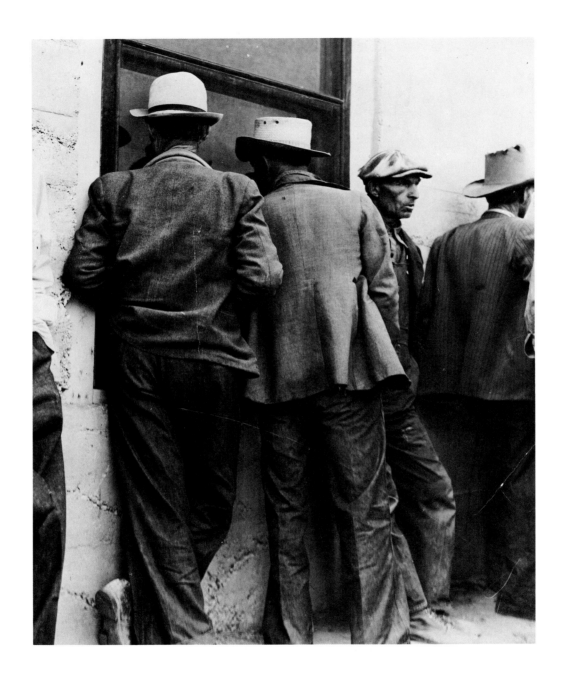

Dorothea Lange
Migrant Mother, Nipomo, California 1936
silver print

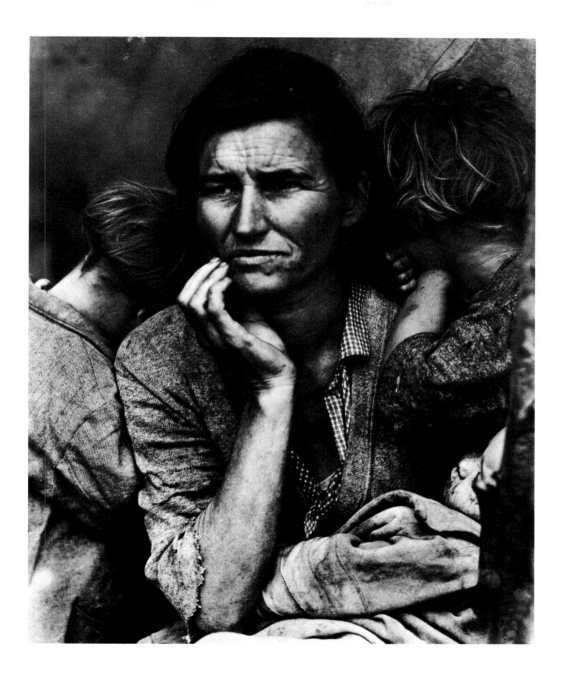

Lewis W. Hine
Workers in a Pa. Coal Breaker January 1911
silver print

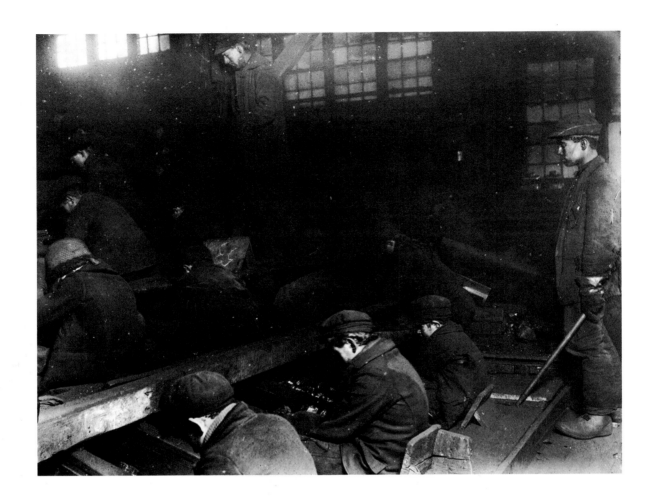

Margaret Bourke White
The Living Dead of Buchenwald April 1945
silver print

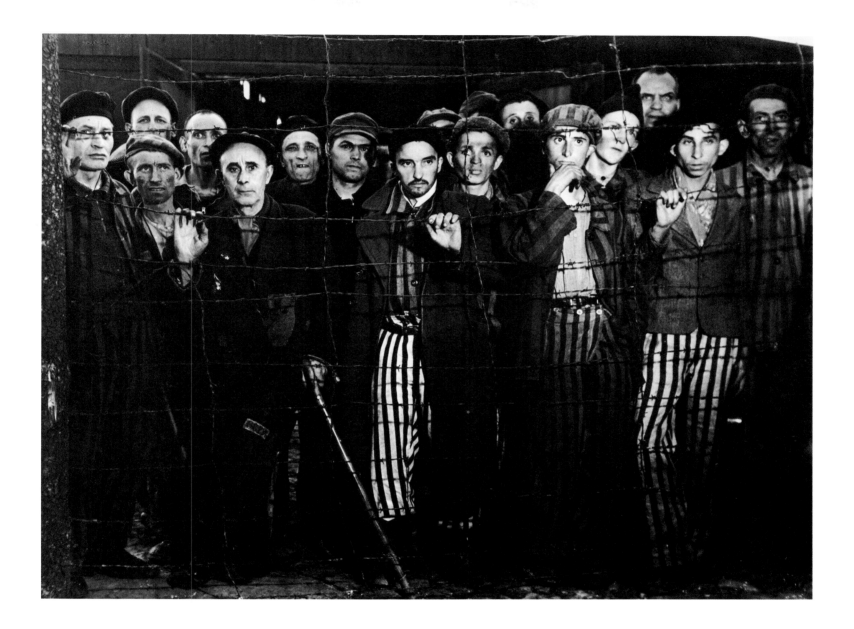

Marion Palfi
In the shadow of the Capitol, Washington, D.C.
1946/1949
silver print

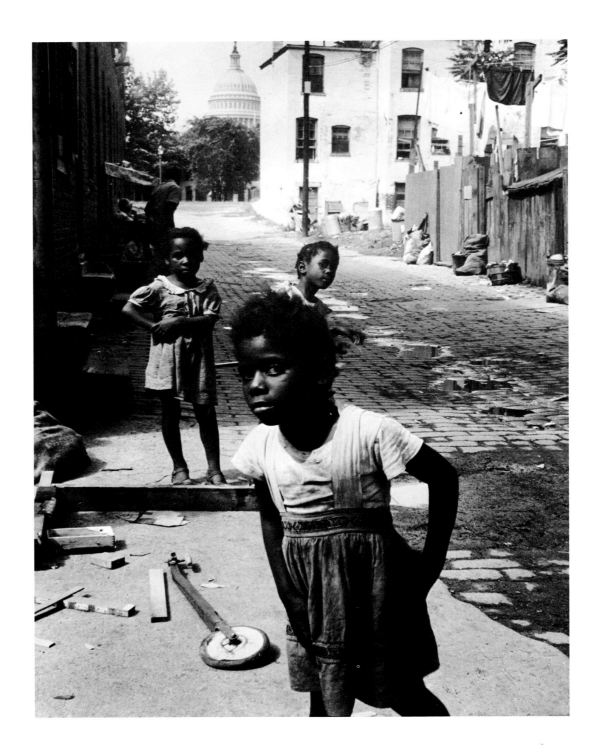

Weegee (Arthur Fellig)
Drink Coca-Cola
silver print

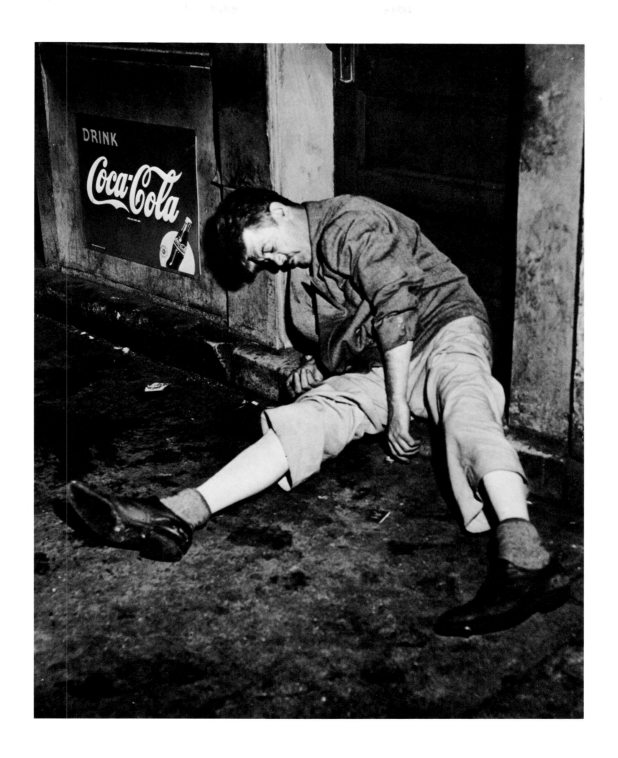

Eadweard J. Muybridge
Abe Edgington Trotting June 15, 1878
albumen print from twelve negatives

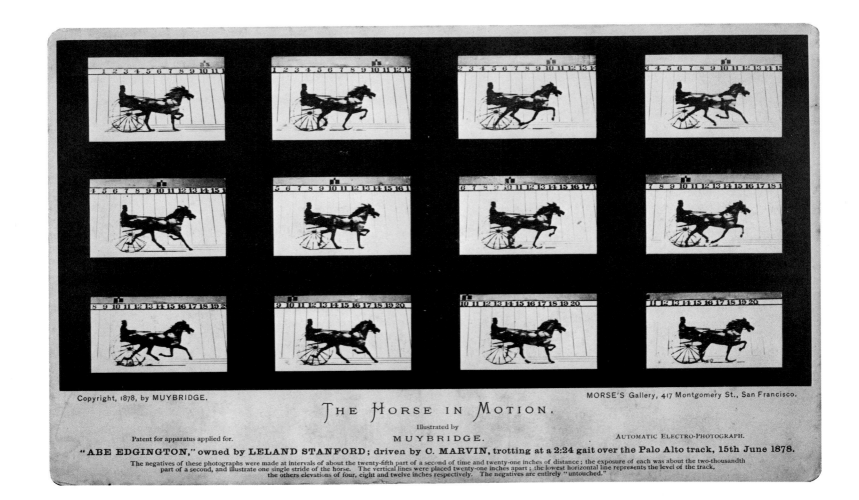

Copyright, 1878, by MUYBRIDGE.

MORSE'S Gallery, 417 Montgomery St., San Francisco.

THE HORSE IN MOTION.

Illustrated by

Patent for apparatus applied for.

MUYBRIDGE.

AUTOMATIC ELECTRO-PHOTOGRAPH.

"ABE EDGINGTON," owned by LELAND STANFORD; driven by C. MARVIN, trotting at a 2:24 gait over the Palo Alto track, 15th June 1878.

The negatives of these photographs were made at intervals of about the twenty-fifth part of a second of time and twenty-one inches of distance; the exposure of each was about the two-thousandth part of a second, and illustrate one single stride of the horse. The vertical lines were placed twenty-one inches apart; the lowest horizontal line represents the level of the track, the others elevations of four, eight and twelve inches respectively. The negatives are entirely "untouched."

The sciences of chemistry and optics made possible the invention of photography; the desire for the invention had its source in the visual arts. Photography has, throughout its existence, continued to serve both parents, and traits of each are recognized in every product of the offspring.

It was an astronomer, François Jean Dominique Arago, Director of the Paris Observatory and member of the French Academy of Sciences, who announced Daguerre's process to the Academy on January 7, 1839. He called to the members' attention the time it took to take a view ("In summer at mid-day, eight to ten minutes suffice") and the importance of the discovery to scientists ("The new substance will also provide physicists and astronomers with very valuable methods of investigation").[1]

Although the statement made by a critic of Daguerre's process, that a moving object "can never be delineated without the aid of memory," was disproved in 1851, when Fox Talbot took a picture with light from an electric flash,[2] the arresting of motion under normal illumination was not achieved until the late 1850s, when Edward Anthony of New York made instantaneous stereographs of street traffic in that city. The results were startling, for they showed attitudes that lasted for so short a time that the eye had not before seen them. But it was not until June 11, 1878, that motion was analyzed photographically. On that day, Eadweard Muybridge made the first serial photographs of fast motion, in a timed series of exposures as fast as "the 1/2000 of a second."

Muybridge's astonishing success (an English author commented that he would have believed it impossible had he not seen proofs of the results) depended upon his shortening the time of exposure usually required by his wet-collodion process; he used the "fastest" lenses available, and himself developed chemical solutions of quick-enough action to record the images. Muybridge concluded his experiments at Palo Alto, California, in 1879 and, after introducing the synthesis of his analytical photographs in a machine of his invention, the zoopraxiscope, to amazed audiences in this country and in Europe, he conducted more elaborate experiments in the analysis of human and animal locomotion at the University of Pennsylvania, in Philadelphia.[3] These studies were initially intended to serve medical science by revealing the motions of spastic or crippled patients at the University Hospital. But of the 781 collotype plates made from Muybridge's photographs, which were published in 1887 under the title *Animal Locomotion*, many are more closely allied to the story-telling successive images of our contemporary, Duane Michals. In fact, the one published on the following pages reverses the motion of Michals' series, *For Balthus*. Muybridge's work introduced a way of seeing that influenced artists as different as Meissonier and Degas, as well as serving scientists.

Berenice Abbott's series of photographs illustrating the laws and processes of physics were made between 1958 and 1961 for the Physical Science Study Committee of Educational Services, Inc. The example in this collection, *Multiple exposure of a swinging ball*, depends upon the stroboscopic effect produced by a revolving black disk with a slit from its center to its edge, which acts as a very fast shutter and makes it possible to record images in quick succession on a single plate. (Muybridge's zoopraxiscope depended upon two such slotted disks, which were counter-rotated; the idea was adapted by him from an optical toy, the stroboscope, introduced by the Austrian inventor, Simon Ritter von Stampfer, in 1832.) Berenice Abbott, despite all the advances in photographic technology that had occurred since 1878, was in as experimental a situation as Muybridge had been when he first took his stop-motion photographs. The descriptions of method, published with the photographs, make us realize the handmadeness (and hand-heldness) of her technology, and belie the technical sophistication of which the prints seem to speak.[4] It was certainly not Berenice Abbott's intention to make photographs that we now see with eyes turned more to aesthetic qualities than to gathering information of physical processes. But she has provided us with both.

The sequences on the following pages devoted to the telling of stories, or the intimation of feelings, are rooted in less specific circumstance, or in the imagination of the photographer. At least two pairs of them, *Husband and Wife* and *The Family*, and the two views from the J. H. Crockwell album, are "found" sequences. And two other sets, one by Duane Michals and the other by Joanne Leonard, use variations of movie techniques. Michals' scenario, however, could hardly be expressed in the cinema; only successive moments of "stills" are up to its poetry. And Joanne Leonard's focus on the umbrella stand is comparable to the standby zoom shot. But in this case, it is we who must zoom.

[1]Quoted in translation in Helmut and Alison Gernsheim, *L.J.M. Daguerre, the History of the Diorama and the Daguerreotype*, New York, Dover, 1968, p. 81.

[2]B. Newhall, *op. cit.*, p. 83.

[3]For further information on Muybridge's work at Palo Alto, see A. V. Mozley, R. B. Haas and F. Forster-Hahn, *Eadweard Muybridge: The Stanford Years*, 1872-1882, Stanford University, Department of Art, revised edition, 1973. For a discussion of his work at the University of Pennsylvania and a valuable resumé of the history of the criticism of his work, see R. B. Haas, *Muybridge: Man in Motion*, Berkeley, University of California Press, 1975.

[4]The descriptions of her method are published with a selection of the photographs in *Berenice Abbott Photographs*, foreword by Muriel Rukeyser, introduction by Davis Vestal, New York, Horizon, 1970, pp. 132-159.

108

Eadweard J. Muybridge
Toilet, Putting on Dress c. 1885
collotype

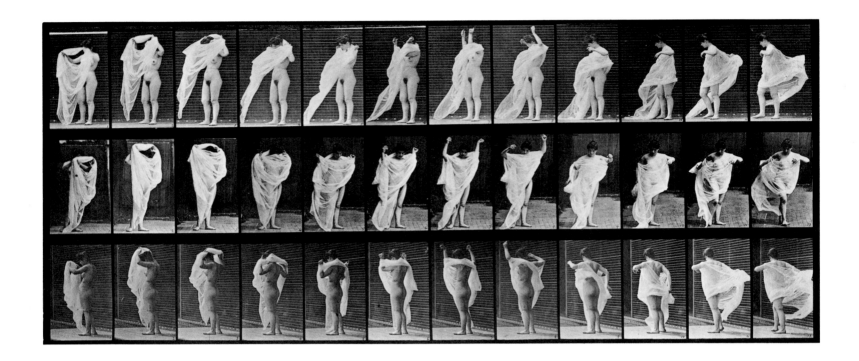

(three frames from facing page)

Unknown
A pair of portraits: *Husband* and *Wife* c. 1885
silver prints, retouched with gouache

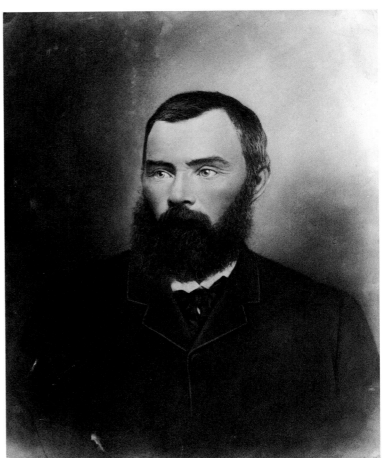

Arlington Studio, Arlington, Washington
Family Portrait c. 1915
silver print with collaged portraits

J. H. Crockwell
Successive views from the album "Souvenir of Park City, Utah" c. 1890
albumen prints

Berenice Abbott
Multiple exposure of a swinging ball 1958/1961
silver print

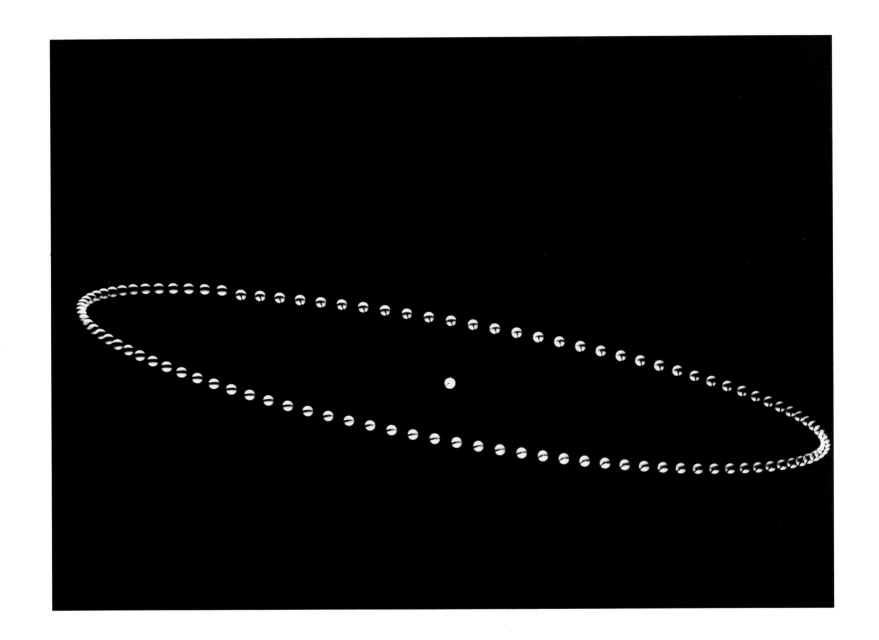

Duane Michals
Death Comes to the Old Lady 1969
silver prints

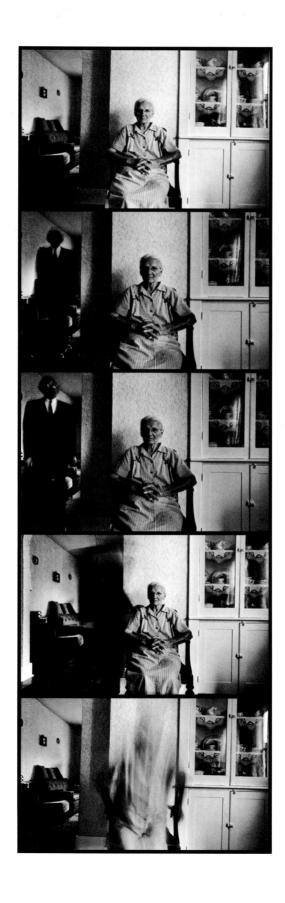

Duane Michals
Death Comes to the Old Lady 1969
silver prints

Joanne Leonard
Two Views in the Morning, Umbrella Stand 1974
silver prints

 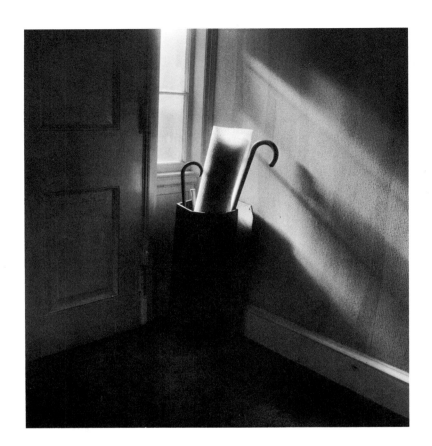

Robert Cumming
Academic Shading Exercise in which the Negative
Proved Closer to Reality 1975
silver prints

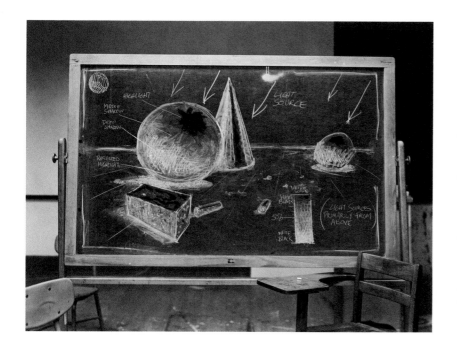

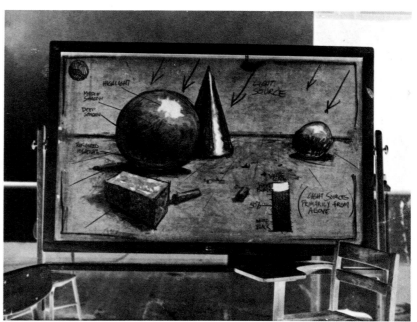

Unknown
Two Brothers by a Table c. 1860
tinted ambrotype

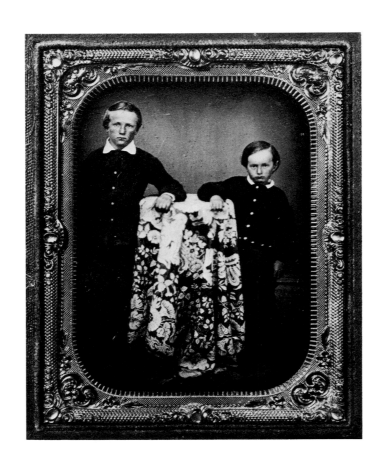

It is an odd sensation, but one which is verified by personal experience, that the concentration of a photographer upon a single object can produce meanings that go beyond what is nominally the subject of the photograph.

The photographer of *Two Young Brothers by a Table*, or rather, the person responsible for coloring the table red, but only tinting the cheeks of the brothers, made the table the *persona* of the daguerreotype that introduces this selection of photographs, many of which speak of meanings extracted from appearance.

Many contemporary photographers are aware of this, although not many pursue this wresting of personal meaning from appearance with the clarity and intelligence of Minor White or Clarence John Laughlin. Laughlin is also an extremely articulate spokesman for his mode of seeing. His statement, following, is a banner under which these photographs can be introduced:

"The physical object, to me, is merely a stepping-stone to an inner world where the object, with the help of subconscious drives and focused perceptions, becomes transmuted into a symbol whose life is beyond the life of the objects we know and whose meaning is a *truly human meaning*. By dealing with the object in this way, the creative photographer sets free the *human contents* of objects; and imparts humanity to the inhuman world around him."[1]

[1]*Clarence John Laughlin: An Aperture Monograph*, introduction by Jonathan Williams, stories by Lafcadio Hearn, captions by the photographer, Millerton, N.Y., *Aperture*, Vol. 17, Nos. 3 & 4, 1973, p. 14; published as the catalogue for *Clarence John Laughlin: The Personal Eye*, Philadelphia Museum of Art, Nov. 1973-Jan-1974.

Unknown
The Washington Monument (begun 1848;
completed 1884)
albumen print

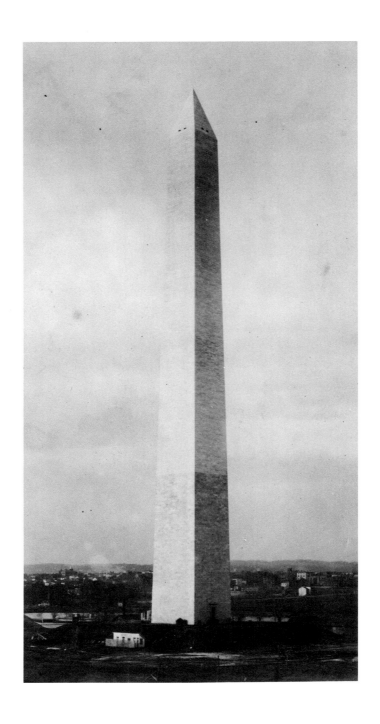

Langenheim Brothers, attributed to
*The Powers Group of Statuary at the New York
Crystal Palace* 1853
salt-paper print

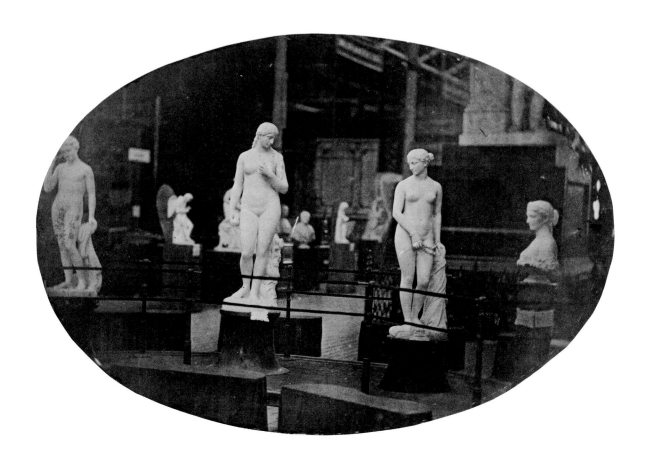

J. S. Johnston, New York
The Yacht "Katrina" c. 1885-1895
albumen print

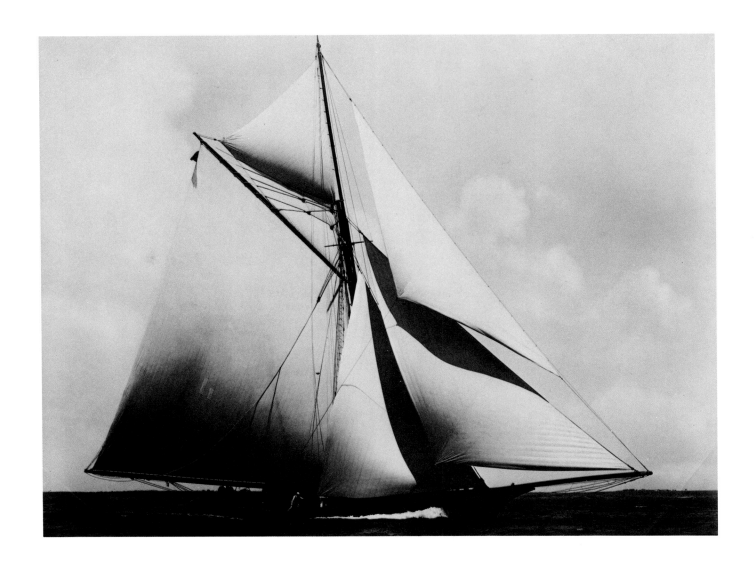

Clarence H. White
Drops of Rain before 1908
photogravure

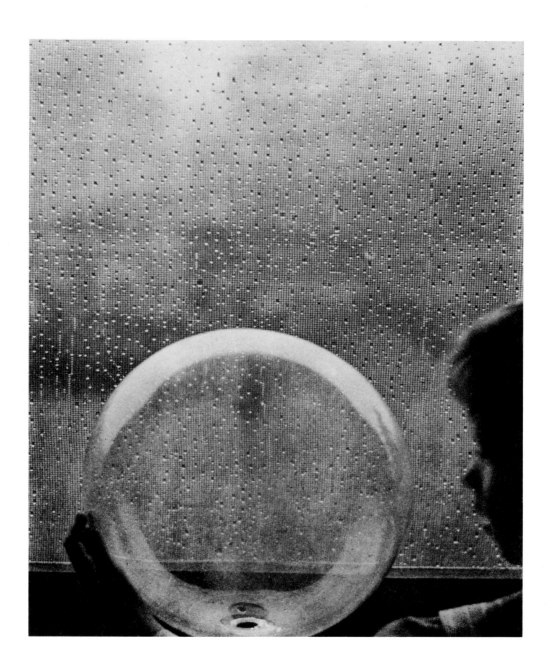

Paul Strand
Abstraction: Porch Shadows 1915
photogravure

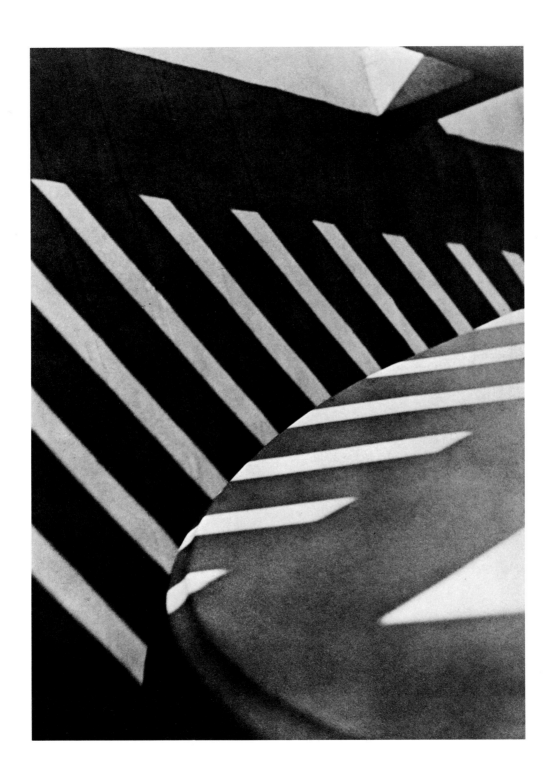

Paul Outerbridge, Jr.
Untitled 1922
platinum print

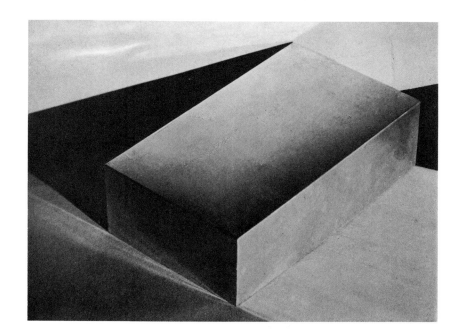

Edward Weston
Torso 1925
silver print

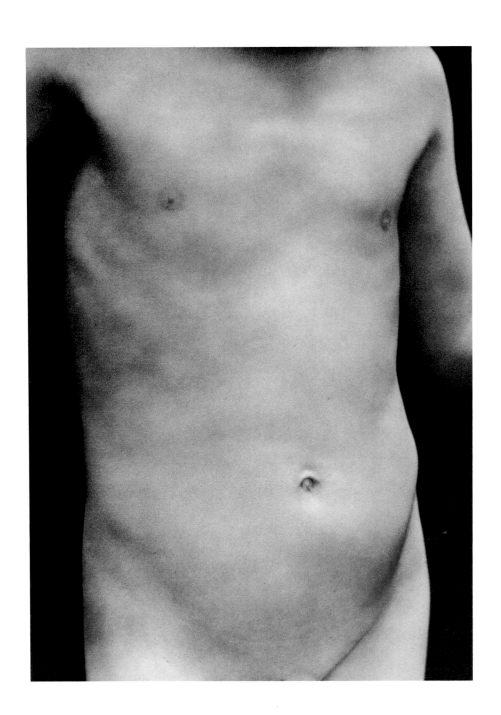

Clarence John Laughlin
The Iron Faces 1939
silver print

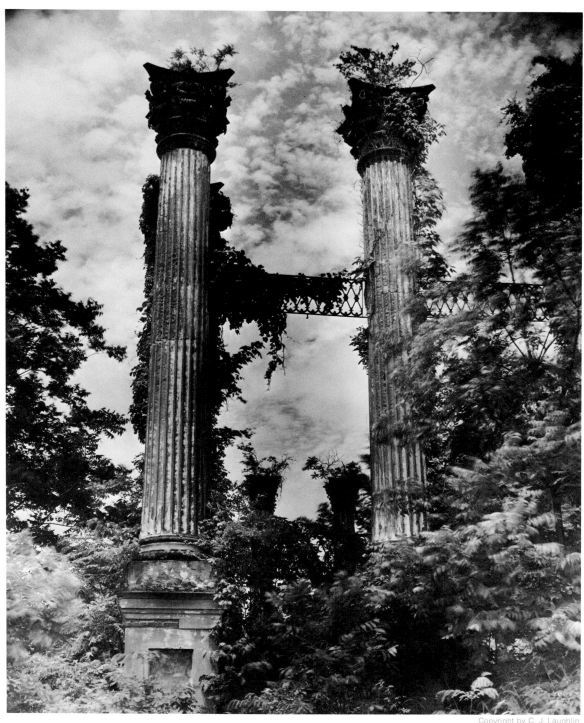

Minor White
Moon and Wall Encrustations, Pultneyville, N.Y.
1964
silver print

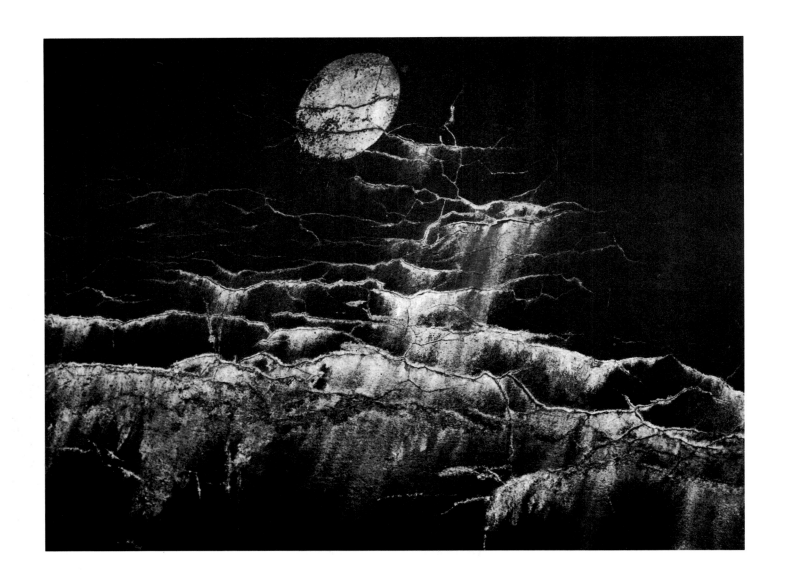

Paul Caponigro
Rock, West Hartford, Connecticut 1959
silver print

Lotte Jacobi
Figure
photogram, silver

Ralph Gibson
Untitled 1967
silver print

Christopher Rauschenberg
Untitled c. 1974
silver print

Lewis Baltz
*Plate 32, "The New Industrial Parks near Irvine,
California"* 1974
silver print

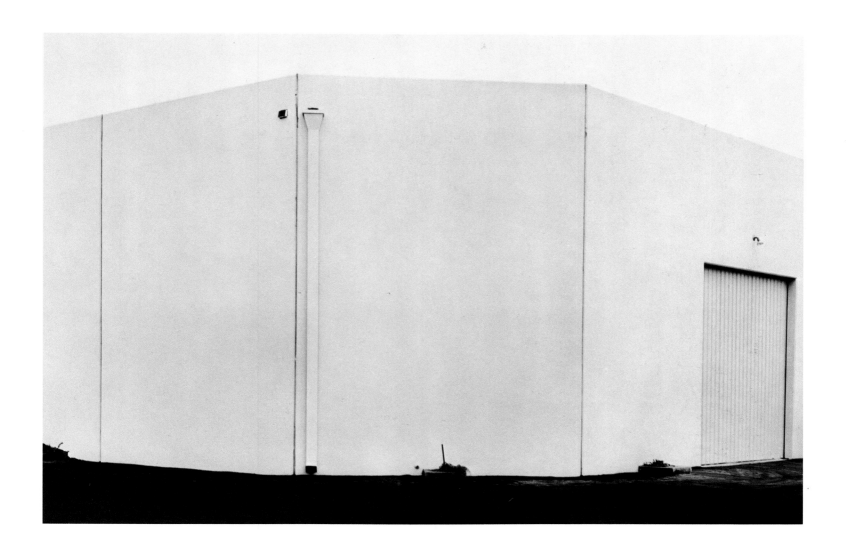

Diane Arbus
Child with a toy hand grenade in Central Park,
N.Y.C. 1962
silver print

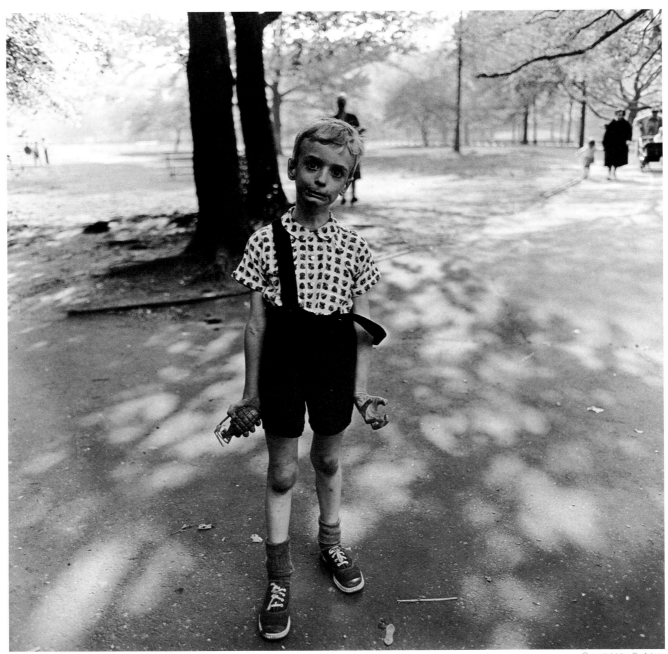

American Photography: *Past into Present*
Catalogue of Selections from the Monsen Collection
of American Photography

Measurements are given in inches; height precedes width. The date of the negative, if it is known, is given following the title. If the print is not approximately contemporary with the negative, the date of the print is given following the name of the paper or process used. Titles are given as inscribed; if no title is inscribed, a descriptive title has been used. Approximate dates are deduced from the process used and from the subject of the image. The entries for silver prints indicate which of them has been made for reproduction, rather than with an exhibition of the print itself in mind. Prints that are illustrated are followed by a letter abbreviation for the section in which they appear, or by a page number.

Berenice Abbott (b. Springfield, Ohio, 1898)

James Joyce Paris, 1928 **P&T**
signed and dated on the mount
silver; 12½ x 10³/₁₆

Exchange Place, New York 1933
signed on the mount
silver, 1974; 18⅛ x 4¾

New York, West Side Looking North from Upper 30s c. 1936 **V-II**
signed on the mount and titled verso
silver, 1974; 13⅜ x 10⅜

Old Post Office, Broadway and Park Row, Manhattan May 25, 1938
titled, dated and inscribed: "Federal Art Project, 'Changing New York,' Photographs by Berenice Abbott"
silver, contact; 9½ x 7⅝

Multiple exposure of a swinging ball 1958/61 **S**
one of a series of photographs made to illustrate laws and processes of physics for the Physical Science Study Committee of Education Services, Inc.
silver; 10½ x 13¾

Ansel Adams (b. San Francisco, 1902)

The Golden Gate before the Bridge 1932
signed on the mount; titled verso
silver. c. 1973; 14 x 19⅝

Winter Sunrise: The Sierra Nevada from Lone Pine 1944
signed on the mount; titled verso
silver, c. 1973; 15⅝ x 19½

Moonrise, Hernandez, New Mexico 1944 **V-I**
signed on the mount; titled verso
silver. c. 1971; 15⅝ x 19⅜

Jim Alinder (b. Glendale, California, 1941)

David, Palace of Living Art, Los Angeles 1974
signed, dated and titled verso
silver; 17⅞ x 8

Michael Andrews (b. Rockford, Illinois, 1945)

Signed and Dated 5 x 7 in. Photograph of the Sand 1973
titled
silver; 16 x 19¾

Thomas Anschutz (Newport, Kentucky 1851-1912 Fort Washington, Pennsylvania)

Boys swimming from a single-oared scull, Philadelphia c. 1881　**p. 154**
Provenance: the artist's studio
cyanotype; 5⅝ x 8

Edward Anthony (active New York City, 1859-1881)
Two stereoscopic views;
albumen; each image 3 x 3

View from Cold Spring, Looking South c. 1859
published by E. & H. T. Anthony ("Beauties of the Hudson River" series), 1871-1873

Fifth Avenue, New York c. 1859
mounted on the E. & H. T. Anthony yellow card

Diane Arbus (New York City 1923-1971)

Child with a toy hand grenade in Central Park, N.Y.C. 1962　**p. 134**
titled and dated verso; estate stamp
silver, printed by Neil Selkirk, c. 1974; 15⅛ x 14¾

A family on their lawn one Sunday in Westchester, N.Y. 1968　**P&T**
titled and dated verso; estate stamp
silver, printed by Neil Selkirk, c. 1973; 10 x 9¾

Masked woman in a wheelchair, Pa. 1970
titled and dated verso; estate stamp
silver, printed by Neil Selkirk, c. 1974; 15¼ x 14¾

Arlington Studio (Dinler & Co.), Arlington, Washington

Family Portrait c. 1915　**S**
silver, with two portraits pasted on; 8¼ x 6⅛

Richard Avedon (b. New York City 1923)

Truman Capote 1958　**P&T**
dated; photographer's stamp verso
silver, reproduction print; 14 x 11

Platt D. Babbitt (active Niagara Falls 1854- c.1870)

Grove Scenery—Winter c. 1860　**V-I**
titled on the photographer's mount
glass positives for the stereoscope; each image 2⅜ x 2⅜

Bacon Studio, New York

A Brother and Sister c. 1860
tinted ambrotype; sixth-plate

Lewis Baltz (b. California, 1945)

Pasadena #2 1973　**V-II**
silver; 6⅛ x 8⅞

Plates 4, 12, 25 and 32 from the portfolio
The New Industrial Parks Near Irvine, California 1974
No. 32, O&B
signed and dated verso; limited (12/21)
silver; 6 x 9

George N. Barnard (1819-1902)

Destruction of General J.D. Hood's Ordnance Train in Georgia 1864
from Barnard's *Photographic Views of Sherman's Campaign* 1866
titled on the mount
albumen; 10½ x 15

Confederate Fortifications in front of Atlanta July 1864
from Barnard's *Photographic Views of Sherman's Campaign*
titled on the mount
albumen; 10¼ x 15

Barrett Studio, New York

General U.S. Grant and Family, at Mt. McGregor June 19, 1885
titled and dated on the studio card
albumen; 3½ x 5⅝

Thomas Barrow (b. Kansas City, Missouri, 1938)

From the Series Pink Stuff (Line) 1971
signed, titled and dated verso
Type "C"; 4⅜ x 13¾

Homage to Paula 1973 neg. (print 1974)
signed, titled, and dated on mount
silver toned; 9¼ x 13½

Cecil Beaton (b. London 1904; active U.S. intermittently)

Gary Cooper c. 1929
signed on the mount
silver, c. 1974; 17¾ x 10

Marlene Dietrich c. 1930
signed on the mount
silver; 17⅞ x 14

William Bell (active Wheeler Expedition in Arizona and Utah, 1872)

Cañon of Kanab Wash, Colorado River, Looking North, No. 2 1872
titled and dated on the Wheeler Expedition mount
albumen; 10¾ x 8

Grand Cañon of the Colorado River, Mouth of Kanab Wash Looking West 1872　**V-I**
titled and dated on the Wheeler Expedition mount; signed on the negative
albumen; 10⅞ x 8

E.J. Bellocq (1873-1949)

Portrait, Storyville, New Orleans c. 1912　**P&T**
contact print by Lee Friedlander, c. 1974; 9 x 7¼

Charles Bierstadt (Salingen, Germany, before 1832-1903 Niagara Falls)

Fifteen stereoscopic views of Niagara Falls; published by Bierstadt and, after 1884, by Underwood & Underwood:
Whirlpool Rapids; Prospect Park (2); Ice Bridge (7); Horseshoe Falls from Below; Under Niagara Falls, Canada (2); American Falls and Ice Bridge; Below Cave of the Winds 1867-1870
titled on the prints
albumen; each image 3⅛ x 3　**V-I**

Michael Bishop (b. Palo Alto, California, 1946)

Untitled No. 2306　**p. 4**
signed, numbered on print
RC print, toned; 14⅝ x 22

Wynn Bullock
The Stark Tree 1956
silver print

James Wallace Black
(New Hampshire 1825-1896 Boston?)

Winthrop Square, Boston, after the great fire of November 9th and 10th, 1872 **D**
on the photographer's mount
albumen; 11½ x 16⅞

Boston, after the Great Fire 1872
titled on the mount
three albumen prints; the view, 10¼ x 39¼

Margaret Bourke-White (New York City 1904-1971)

The Living Dead of Buchenwald April 1945 **D**
photographer's stamp verso
silver, for reproduction; 11 x 14

Matthew Brady, attributed to (b. New York State c. 1823-1896 New York City)

Abraham Lincoln 9 February 1864
dated on the mount
albumen from copy negative; 5½ x 4

Anne W. Brigman (Honolulu 1869-1950 Oakland, California)

Dryads
photogravure, as published in *Camera Work* 44, Oct. 1913

Francis Bruguière (San Francisco 1880-1945 London?)

A Portrait
photogravure, as published in *Camera Work* 48, Oct. 1916

Wynn Bullock (Chicago 1902-1975, Monterey, California)

The Stark Tree 1956 **p. 137**
Navigation without Numbers 1957
Child on a Forest Road 1958
Erosion 1959 **V-I**
The Shore 1966
signed, titled and dated, except for *Navigation*
silver prints; c. 7½ x 9¼, except *The Shore*, 9¼ x 13½

Rudy Burckhardt (b. Basel, Switzerland, 1919)

Flatiron in Summer 1948 **V-II**
photographer's stamp verso
silver, 1975; 12¼ x 10

Harry Callahan (b. Detroit, Michigan, 1912)

Facade, Wells Street, Chicago 1949 **V-II**
signed on the mount
silver, c. 1973; 6½ x 6⅞

Eleanor, Port Huron 1954
signed on the mount
silver, c. 1973; 6⅝ x 6½

New York 1967/68
signed on the mount
silver, c. 1973; 10½ x 10⅜

Paul Caponigro (b. Boston 1932)

Rock, West Hartford, Connecticut 1959 **O&B**
silver; 10 x 12½

Garden, Brewster, New York 1963 **p. 139**
negative print; 9⅛ x 7⅜

Monument Valley, New Mexico 1970
signed on the mount
silver; 6⅞ x 8⅝

Alvin Langdon Coburn (Boston 1882-1966 Wales)

Alfred Stieglitz, Esq.
photogravure, as published in *Camera Work* 21, January 1908
diam. 6¼

Photogravure plates from *New York*, 1910 ("A Companion Volume to Coburn's London . . . Twenty Beautiful Photogravures from Original Photographs by Alvin Coburn, Folio half leather, price $6.00 net. With Essay on New York by H.G. Wells, the Famous Novelist. Brentano's New York.")
The Singer Building;
Fifth Avenue from the St. Regis; **V-II**
Broadway and the Singer Building by Night;
The Holland House

Mark Cohen (b. Wilkes-Barre, Pennsylvania, 1943)

May 1973, Luzerne, Pa.
signed, dated and titled verso
silver; 11⅞ x 17¾

J. H. Crockwell, Salt Lake City

Views from the album *Souvenir Views of Park City, Utah,* 1890:
Hot Pot; Skilit on Hot Pot (both **S**); *Ontario Mine and Canyon; Picnic Party at Brighton; Mine Shaft* **p. 9**
albumen; 5½ x 8¼

Robert Cumming (b. Worcester, Massachusetts 1943)

Academic Shading Exercise in Which the Negative Proved Closer to Reality 1975 **S**
signed, titled and dated on the mount
silver, negative and positive prints; each, 9½ x 7½

Imogen Cunningham (b. Portland, Oregon, 1883)

On Mt. Rainier 1915 **V-I**
platinum; 7⅜ x 9⅝

Magnolia Blossom 1925
signed and dated on the mount
silver, 1974; 9½ x 12

My Father at Ninety 1936
signed and dated
silver, 1974; 8⅝ x 11¼

Edward S. Curtis (Wisconsin, 1868-1955 Los Angeles, California)

The Three Chiefs–Blackfoot 1900
The Vanishing Race–Navajo 1904
both with the Curtis Studio (Seattle) stamp verso
orotone prints; 10½ x 13½

Photogravure plates from the *North American Indian,* 20 vols., 1907-1930:

Vol. I
Nayenèzgani–Navaho 1904 **P&T**
Zanadolzha–Navaho 1904
both on Japan tissue

Paul Caponigro
Garden, Brewster, New York 1963
negative silver print

Vol. X
Nane-Qagyuhl 1914
on vellum; 7½ x 5⅝
Photogravure plates from the Supplementary Portfolios to
The North American Indian:

Vol. IV
Wolf–Apsaroke 1908
Lone Tree–Apsaroke 1908

Judy Dater (b. Los Angeles, California, 1941)

Lucia 1972
silver; 9⅝ x 7⅝

John Divola (b. Santa Monica, California, 1949)

Untitled, from the "Vandalism" series 1974
signed and dated verso
silver; 7 x 7

Elite Studio, San Francisco

Helen Blythe 1881 **P&T**
titled and dated on the studio card
albumen; 6½ x 4¼

Frank Eugene (New York 1865-1936
Leipzig, Germany)

Professor Adolf von Seitz
signed on the plate
photogravure, as published in *Camera Work* 31, July 1910

Walker Evans (St. Louis 1903-1974 New York)

Main Street, Saratoga Springs 1931 **V-II**
silver (contact); 8⅛ x 6½

Alabama Farmer's Wife 1936 **P&T**
reproduced through the courtesy of the Farm Security
Administration in James Agee and Walker Evans,
Let Us Now Praise Famous Men, 1941
signed on the mount
silver; 9³/₁₆ x 7⅜

Benjamin J. Falk (1853-1925)

Portrait of Miss Rush, the Actress c. 1885
inscribed by Miss Rush
silver; 11⅝ x 7

George Robinson Fardon (England
1806-1886, active San Francisco and Victoria B.C.
1849-1862)

Panoramic View of San Francisco 1855
seven paper prints; the panorama 7¼ x 51¾

George Fiske (active Yosemite, 1880s)

General View of Yosemite from Artist Point
signed on the negative, titled and photographer's
stamp verso
albumen; 4⅝ x 7½

Fox & Symons Studio ("Artists and Artistic
Photographers, Salt Lake City")

J.E. Butler, 12 Wd. Meat Market c. 1885 **P&T**
albumen; 5¾ x 8½

Lee Friedlander (b. Aberdeen, Washington, 1934)

T.V. 1-11-U.S. 1961
signed, titled and dated; photographer's stamp
silver; 5½ x 8⅜

(see also E. J. Bellocq entry)

Untitled (sunbathers in the city) c. 1969
photographer's stamp and limitation (20/23) verso
silver; 6¼ x 8¾

Oliver Gagliani (b. Placerville,
California, 1917)

Untitled 1975
signed and dated on the mount
silver; 11 x 14

Alexander Gardner, attributed to
(Paisley, Scotland 1821-1882 Washington, D.C.)

Ruins in Richmond April 1865
from Gardner's *Photographic Sketch Book of the
Civil War*, 1866
albumen; 6⅛ x 10⅜

Garo Studio, Boston

Two portraits of **Dorothy Snyder** c. 1915
both titled on the studio mount
platinum; 17¾ x 14¾ (oval) and 12⅝ x 9¾

Arnold Genthe (Berlin 1869-1942 New York)

Reading the Tong Warnings San Francisco, c. 1903
photographer's stamp verso
silver, toned; 12¼ x 8⅞
published in Arnold Genthe, *Pictures of Old Chinatown*,
1908 (1st edition) and in A. Genthe, *Old Chinatown*, 1913

New Orleans Plantation c. 1924 **p. 141**
signed on the mount
silver; 10¼ x 13⅛

Ralph Gibson (b. Los Angeles 1939)

Untitled 1967 **O&B**
signed, dated and limited (10/25) on the sheet
silver; 12¾ x 8⅝

Laura Gilpin (b. Colorado Springs 1891)

Bryce Canyon No. 2 1930 **V-I**
signed and dated
platinum; 9⅝ x 7⅝

Geotzman, Dawson City

Panorama of Dawson City, Yukon Territory
October 5, 1901
signed, dated and titled on the negative
five panels, silver; each 11¾ x 13¾

Three copy enlargements, silver prints; 14½ x 19:
*En Route to the Klondike Gold Fields–
Chilkoot Pass
Summit of Chilkoot Pass, Spring of 1898
Over the Chilkoot Pass*
signed and dated on the negative

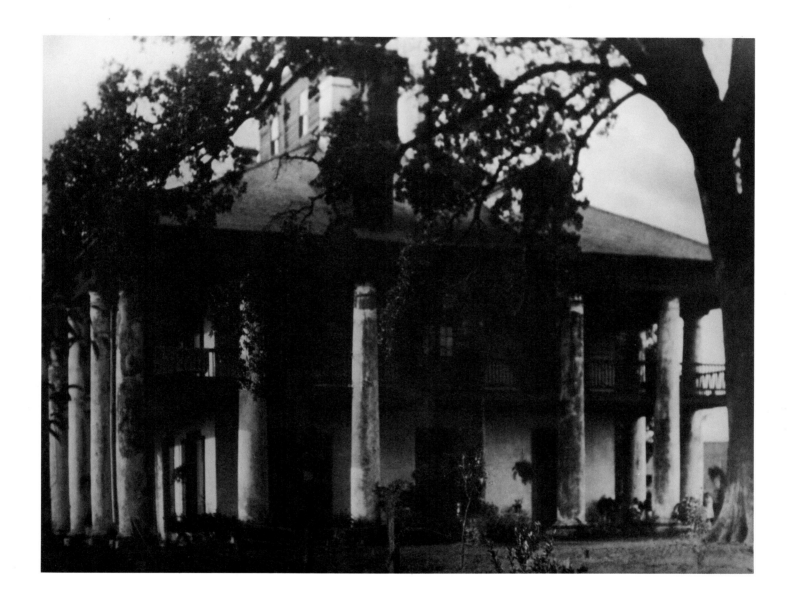

Arnold Genthe
New Orleans Plantation c. 1924
silver print

Frank Gohlke (b. Wichita Falls, Texas, 1942)

Landscape with irrigation canal,
Albuquerque 1974　**V-I**
signed and dated on print verso
silver; 13⅛ x 13⅛

Emmet Gowin (b. Danville, Virginia, 1941)

Barry, Dwayne and Turkeys,
Gainsville, Maryland 1969　**P&T**
signed, dated and titled verso
silver; 5½ x 7

Peat Drying, Isle of Skye 1972　**V-I**
silver; 7⅜ x 8½

Jeremiah Gurney (active New York City, 1840)
studio proprietor in various cities-after 1865)

A Man with Side Whiskers c. 1850
daguerreotype; half-plate

Gary Hallman (b. St. Paul, Minnesota, 1940)

East Minehaha c. 1972
signed and titled
silver; 21⅞ x 32½

F. Jay Haynes (Saline, Michigan 1853-1921
St. Paul, Minnesota)

Liberty Cap and Hotel, Yellowstone
National Park c. 1885　**V-I**
signed and titled on the negative
albumen; 7¼ x 21¾

Loudolph Hensel (Hawley, Pennsylvania
active c. 1868-1878)

Three views of Pike County, Pennsylvania:
Looking Downstream above High Falls; The
Soap-Trough at Dingman's; Fulmer Falls,
Dingman's Creek
mounted on cabinet cards with photographer's label and
list of forty-six views verso, "Price, $2.00 per dozen."
albumen; each, 6⅛ x 4⅛

Wilhelm Hester (Hamburg, active Tacoma and
Seattle, 1893-1915)

Under the Rigging　**p. 143**
albumen; 7½ x 9½

John K. Hillers (1843-1925; active Powell Survey,
1872-1878)

Pueblo, New Mexico after 1873　**V-II**
albumen; 9⅞ x 13

Makun-to-wip Valley, Utah
albumen; 10⅞ x 13

Winslow's Cascade on Winslow's Creek, Utah
1875　**V-I**
albumen; 9¼ x 7⅛

Three stereoscopic views from Powell Surveys:
Alcove Wall, from "Views on Brush Creek" (Utah
Territory)
At the Water Pocket, from "Views on the Kai-Par-O-
Wits Plateau;" (Southwestern Utah)
Annie's Glen, from "Views on Winslow Creek" (Utah
Territory) 1875
on the Powell Survey mounts; titled on the Survey label,
verso
albumen; each image 4⅜ x 4⅛

Lewis W. Hine (Oshkosh, Wisconsin 1874-
New York 1940)

Boys in a Textile Mill (1908/1916)
National Child Labor Committee negative 263
silver, for reproduction; 4¾ x 6¾

Workers in a Pa. Coal Breaker, Jan. 1911　**D**
titled, dated, photographer's stamp and descriptive label
verso: "Dust so thick it obscured the view much of the
time. The boys bend over the constant streams of broken
coal, picking out slate. A boss . . . stands over them,
prodding or kicking the boys into obedience."
silver, for reproduction; 7½ x 9½

Power House–Mechanic on Steam Pump 1925
signed verso; published in Hine, *Men at Work*, 1932
silver, for reproduction; 9⅝ x 6⅞

Bachelor Miner Working in Scott's Run Coal
Mine, West Virginia, 1936
titled, dated and photographer's stamp verso
silver, for reproduction; 7⅝ x 9½

T.E. Hinshaw (itinerant, out of Chicago)

George F. Tilson, M.D. c. 1895　**P&T**
titled on the studio card
albumen; 6½ x 4¼

S.A. Holmes, New York City, attributed to

A Woman and Three Men Posed by
Niagara Falls c. 1858　**P&T**
tinted ambrotype; half-plate

Horst P. Horst (b. Germany, 1906)

Marlene Dietrich c. 1940
signed on the mount
silver, 19 x 15⅛

William H. Jackson (1843-1942 New York)

Gibbon Falls, 84 feet 1871
titled on the negative
albumen; 8½ x 7

Hot Springs on Gardner's River, Upper Basin
1871　**V-I**
titled and signed on the negative
albumen; 6¾ x 8⅞

Grand Canyon of the Yellowstone and Falls 1871
titled
albumen

Minerva Terrace, Mammoth Hot Springs 1871
titled on the negative
albumen; 7 x 8½

attributed variously to Jackson or to Charles R. Savage:
Quarrying Granite in Cottonwood Canyon for
the Mormon Tabernacle 1872　**V-I**
albumen; 6½ x 8½

Little Shoshone Falls 1880?
titled and signed on the negative
albumen; 9⅞ x 13

Cañon of the Rio Las Animas after 1880　**V-I**
titled and inscribed on the negative: "W.H. Jackson & Co.
Phot., Denver Col."
albumen

Two stereoscopic views from "Garden of the Gods and
Monument Park" series:
Pikes Peak from the "Twins" after 1880
Anvil Rock
albumen; each image 3¾ x 3⅛

Lotte Jacobi (b. Austria 1896)

Figure n.d.　**O&B**
photogram, silver; 6½ x 4½ (sight)

Wilhelm Hester
Under the Rigging c. 1905
albumen print

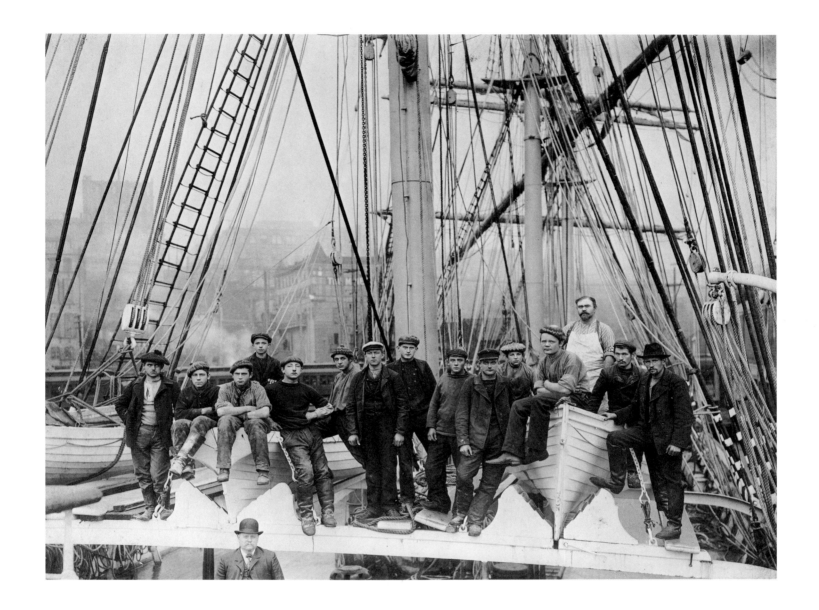

Darius Kinsey
Loggers and Steam Donkey
albumen print

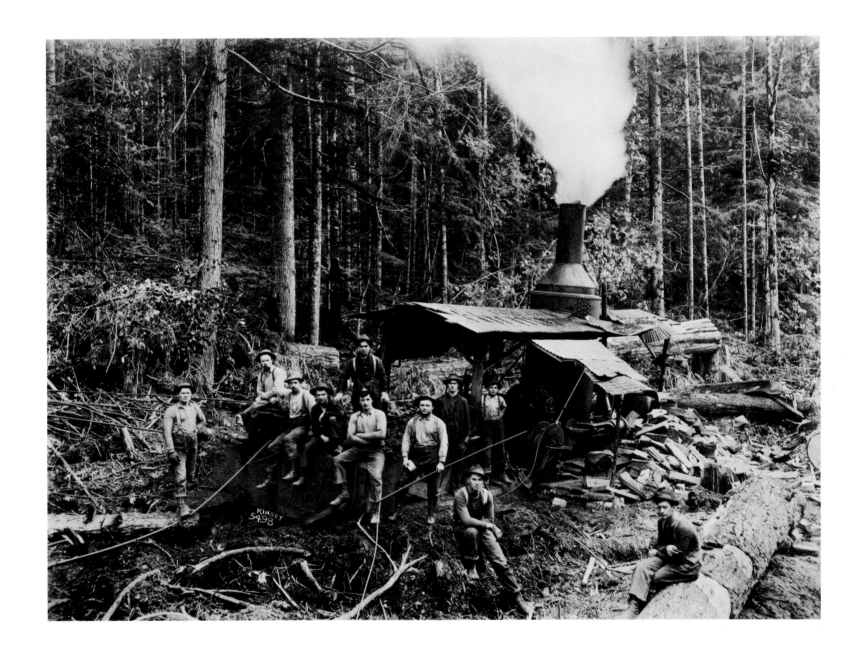

J.S. Johnston, New York

Three yacht portraits:
Vigilant, Kathleen and *Katrina* **O&B**
c. 1885-1895
titled on the negative
printing-out paper; 6⅝ x 8⅜

Gertrude Käsebier (Iowa 1852-1934 New York)

Nancy, Paul (at 3½) and Claire (at 5 months)
c. 1903
signed on the mount
platinum; diameter 5⅞

Portrait of Miss N. **P&T**
photogravure, as published in *Camera Work* 1,
January 1903

Portrait–Miss Minnie Ashley
photogravure, as published in *Camera Work* 10,
April 1905

The Picture-book 1902
photogravure, as published in *Camera Work* 10, April
1905

Darius Kinsey (Missouri 1871-1945 Seattle)

Loggers and Steam Donkey **p. 144**
albumen; 10½ x 13½

H. S. Klein, Los Angeles

Drama **(P&T)**
Music 1896
both signed and dated on the negative
silver, toned; 18 x 24

Les Krims (b. Brooklyn, New York, 1943)

Mom's Snaps 1970 **P&T**
silver, toned; 7⅛ x 4⅞

Victor Landweber (b. Washington, D.C., 1943)

Hand Series No. 3, "Armed Figures" 1972
signed on the mount; titled and dated verso
silver, 1975; 7⅛ x 10½

Dorothea Lange (Hoboken, New Jersey,
1895-1965 California)

Migrant Mother, Nipomo, California 1936 **D**
silver print by Arthur Rothstein 1974; 9½ x 7⅝

Waiting for relief checks at Calipatrin, California
March 1937 **D**
Farm Security Administration stamp and titled verso
silver, for reproduction; 9⅝ x 7⅝

*Migrant Agricultural Worker, near Holtsville,
California* 1937
Farm Security Administration stamp and titled, verso
silver, for reproduction 7¾ x 9 ¾

Frederick Langenheim

*Home of Washington Irving, Sunnyside,
Irvington, N.Y.* 1856 **V-II**
titled and dated on the Langenheim mount
glass positives for the stereoscope, tinted; each, 3¼ x 3¼

Langenheim Brothers, attributed to

*The Powers Group of Statuary at the New York
Crystal Palace* 1853 **O&B**
titled on the mount
salt paper; oval, 5¼ x 7⅛

Clarence John Laughlin (b. Lake Charles,
Louisiana 1905)

The Iron Faces 1939 **O&B**
signed
silver; 9⅝ x 7⅝

Russell Lee

*Unemployed Workers in front of shack with Xmas
Tree, E. 12th St. N.Y.C.* 1936 **D**
Farm Security Administration stamp and titled verso
silver, for reproduction; 6½ x 9½

Joanne Leonard (b. Los Angeles 1940)

Two Views in the Morning, Umbrella Stand
1974 **S**
signed, titled and dated
two silver prints; each, 7¼ x 7⅛

Charles F. Lummis (Lynn, Massachusetts
1859-1928 Los Angeles)

Indian Archer c. 1891
cyanotype; 7 x 4⅜

Spring Foot Races, Pueblo of Isleta, N.M.
titled and copyrighted 1891 on the negative
cyanotype; 4⅜ x 6½

Ralph Eugene Meatyard (Normal, Illinois,
1925-Lexington, Kentucky 1972)

Untitled 1964 **P&T**
silver print by the Center for Photographic Studies, 1973;
7⅜ x 8½

Untitled (stairway group) c. 1964
silver print by the Center for Photographic Studies, 1973;
6⅝ x 7

Roger Mertin (b. Bridgeport, Connecticut, 1942)

Rochester, N.Y. c. 1965 **p. 146**
silver; 8⅜ x 12⅜

Baron Adolph de Meyer (England
c. 1875-1946 Hollywood)

Still Life (Water Lilies)
photogravure as published in *Camera Work* 24,
October 1908

Duane Michals (McKeesport,
Pennsylvania 1936)

René Magritte 1965 **P&T**
signed, titled and limited (15/25)
silver; 4⅝ x 7

Death Comes to the Old Lady 1969 **S**
signed, titled and limited (6/25)
silver; a series of five prints, each 3½ x 5¼

Lisette Modell (b. Austria, 1906)

Gambler Type, French Riviera 1938
silver, c. 1974; 19⅜ x 15⅜

Roger Mertin
Rochester, N.Y. c. 1965
silver print

Barbara Morgan (b. Kansas, 1900)

Martha Graham–"Letter to the World" 1940 **P&T**
signed, titled and dated on the mount
silver, c. 1974; 15 x 19½

J.W. & J.S. Moulton, Salem, Massachusetts

Boston–View in the Public Garden c. 1875
from the "New Series, American Scenery, Boston & Vicinity"
on the publisher's mount
albumen stereogram; each image 4¼ x 3⅛

Eadweard Muybridge (England 1830-1904; active U.S., 1867-1886)

Cottonwood Bend (No. 15, "Valley of the Yosemite" series) 1872 **V-I**
Sylvan Bar (No. 16, "Valley of the Yosemite" series) 1872
published by Bradley & Rulofson, San Francisco, 1873
albumen; both 17 x 21⅜

Panorama of San Francisco from the California Street Hill 1877 **V-II**
published by Morse, San Francisco, 1877
titled and photographer's imprint
eleven panels; the panorama, 7⅜ x 90¾

Abe Edgington Trotting June 15, 1878 **S**
from the series "The Horse in Motion," published by Morse, San Francisco, 1878
photographer's and publisher's imprint; titled and described as an "Automatic-Electro Photograph"
albumen, from twelve negatives; each image 1 x 1½; the card, 5¼ x 8½

Toilet, Putting on Dress c. 1885 **S**
Plate 416, *Animal Locomotion,* University of Pennsylvania, 1887
"Model 13," nude, 12 lateral views, 12 views 90° front, 12 views 60° rear

Arnold Newman (b. New York, 1918)

Alfried Krupp 1963 **P&T**
signed and titled on the mount
silver, c. 1973; 13¾ x 10½

Elaine and Joseph Monsen 1975 **p. 10**
silver, master print; 9³/₁₆ x 7½

C.H. Nielson Studio, Niagara Falls, New York

Niagara Falls c. 1880 **V-I**
on the studio mount
albumen; 15⅝ x 19¼

Wallace Nutting (Massachusetts 1861-1941)

A Great Wayside Oak c. 1930
signed and titled on the mount
silver, hand-colored; 7⅝ x 9½

Timothy H. O'Sullivan (New York City 1840-1882 Staten Island; active Civil War; King Exploration, 1867-69; Darien Survey, 1870; Wheeler Expedition, 1871, 1873-1874)

A Harvest of Death Gettysburg, July 1863 **D**
positive by Alexander Gardner for his *Photographic Sketchbook of the Civil War,* 1866
albumen; 6⅞ x 8⅞
with accompanying descriptive text: "Such a picture conveys a useful moral: It shows the blank horror and reality of war, in opposition to its pagentry. Here are the dreadful details: Let them aid in preventing such another calamity falling upon the nation."

Shoshone Falls, Snake River, Idaho 1874 **V-I**
photographer's name inscribed on the Wheeler Expedition mount, and the description: "Mid-day view, Adjacent walls about 1000 feet in height."
albumen; 8 x 10⅞

Paul Outerbridge, Jr. (1896-1958)

Untitled 1922 **O&B**
signed on the mount
platinum; 3½ x 4½

Shirt Collar 1922 **p. 148**
made for Geo. P. Ihde & Co., Berlin, manufacturers
signed on the mount
with the label of the International Salon of the Pictorial Photographers of America, May 1923, New York City
platinum; 4⅝ x 3⅝

Marion Palfi (b. 1917)

In the Shadow of the Capitol–Washington, D.C. 1946/49 **D**
signed on the mount
used as illustrating testimony in the 81st Congress (1951) on behalf of the national school lunch program and of low income families. "In the late 1950s and the early 1960s black people throughout the South had this photograph in the windows of their homes."— M. Palfi
silver; 13⅞ x 10⅝

Abigail Perlmutter

Woman and Boat 1975
signed and dated verso
silver; 12 x 18

Gerald Piel (b. Los Angeles 1928)

Truck
signed verso
color; 9¼ x 14

Marion Scott Post (b. 1910)

Swimming in fountain across from Union Station, Washington, D.C. c. 1937
Farm Security Administration stamp; titled
silver, for reproduction; 6½ x 9½

William H. Rau, Philadelphia

Towanda from Table Rock, Lehigh Valley Railroad c. 1885
signed and titled on the negative
inscribed: "The Switzerland of America"
albumen; 17¼ x 20⅜

Christopher Rauschenberg (b. New York City, 1951)

Untitled c. 1974 **O&B**
signed on the mount
silver; 5⅜ x 8

Man Ray (b. Philadelphia, 1890)

Hands and Rose 1934 **P&T**
signed on the print
silver, solarized; 13⅝ x 10⅝

Every Picture Tells a Story Paris 1935
titled and inscribed: "Russian mannequin poses in 'Chanel's Picture Dress' of black taffeta and tulle. Man Ray's photo for *Harper's Bazaar.*"
silver; 11¼ x 9

148

Paul Outerbridge, Jr.
Shirt Collar 1922
platinum print

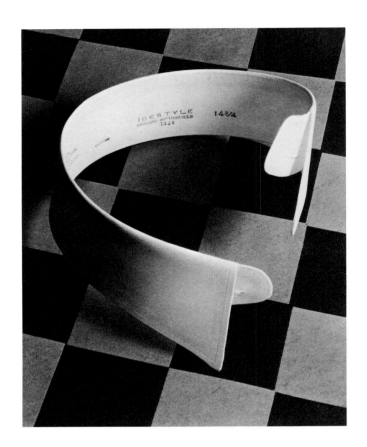

Leland Rice (b. Los Angeles, 1940)

Wall Site 1973
silver; 12¾ x 9⅞

F.A. Rinehart, Omaha

Hattie Tom, Apache **P&T**
signed, titled and copyright date (1899) on the negative
photogravure; 9 x 7⅛

Arthur Rothstein (b. New York City, 1915)

Dust Storm, Oklahoma 1936
signed on the sheet
silver, c. 1974; 10 x 10

Andrew Joseph Russell (1830-1902
New York City)

Bridge 32 Across Weber River (along the Union
Pacific Line) c. 1868
titled
albumen; 8⅝ x 12⅜

Hanging Rock, Echo City, Utah c. 1868 **V-I**
Plate XVII, F.V. Hayden, *Sun Pictures of Rocky Mountain
Scenery*, 1870
albumen, copy reduction; 6 x 7⅞

**Napoleon Sarony and Benjamin
Richardson** (1821-1896 and 1834-1925)

The Actor Henry E. Dixey c. 1875 **P&T**
titled on the studio mount
albumen; 7⅛ x 11¾

The Rev. H.W. Beecher, 1813-1884 c. 1880
titled on the studio mount
albumen; 13 x 7¼

Charles R. Savage (1832-1909; active Salt
Lake City after June 1860)

attributed variously to Savage or to William H. Jackson;
*Quarrying Granite in Cottonwood Canyon for
the Mormon Tabernacle* 1872 **V-I**
titled
albumen; 6½ x 8½

Salt Lake from Prospect Hill c. 1880 **V-II**
signed and titled on the negative
albumen; 9⅛ x 11

*Laying the Capstone on the Mormon Temple,
April 6th, 1892*
signed and titled on the negative
albumen; 17¼ x 21¼

George H. Seeley (Stockbridge, Mass.
1880-1955)

Blotches of Sunlight and Spots of Ink
photogravure, as published in *Camera Work* 20,
October 1907

Ben Shahn (Lithuania 1898-1969 New Jersey)

*Jeeter Gentry, Elmer Thompson and Fiddlin' Bill
Henseley, Ashville, North Carolina* c. 1936
Farm Security Administration stamp and titled verso
silver; 6⅜ x 9½

Aaron Siskind (b. New York City, 1903)

Arch of Constantine, 4 1967
signed and titled verso
silver; 13½ x 10½

Stephen Shore (b. New York City, 1947)

Bay Theater, 2nd Street, Ashland, Wisconsin
July 9, 1973
signed, titled and dated verso
C print; 6¼ x 8⅜

Holden Street, Norton Adams, Mass. July 31, 1974
signed, titled and dated verso
7½ x 9½

W. Eugene Smith (b. Wichita, Kansas, 1918)

Pittsburgh 1955/1956
photographer's stamp verso
silver, c. 1973; 9 x 12¾

Charlie Chaplin on the Set of Limelight 1952
titled
silver; 9¼ x 13⅜

Tomoko in her Bath 1972 **P&T**
signed on the print
silver; 11⅝ x 18½

Peter Stackpole (b. San Francisco, 1913)

Building the Golden Gate Bridge 1935
signed
silver; 5⅞ x 8⅝

The Golden Gate Bridge: A Tower c. 1938
signed
silver; 9 x 6⅛

Edward J. Steichen (Luxembourg 1879-1973
Connecticut)

The Pool
photogravure, as published in *Camera Work* 2, April 1903

Moonlight: The Pond 1903 **V-I**
photogravure, as published in *Camera Work* 14,
April 1906
signed and dated on the plate

J. Pierpont Morgan, Esq. 1903 **P&T**
photogravure, as published in *Camera Work* 14,
April 1906
signed and titled on the plate; copyright 1904

Portrait of Clarence H. White
photogravure, as published in *Camera Work* 9,
January 1905

Houseboat on the Thames 1907
George Bernard Shaw 1907
four-color halftones (Lumière Autochrome Process), as
published in *Camera Work* 22, April 1908
"A special supplement to *Camera Work* is in the course of
preparation. It is to deal with this new color photography.
Steichen is preparing the text. The celebrated firm of
Bruckmann, in Munich, early in July received the order to
reproduce four of Steichen's early efforts for the book.
They are the pictures of Lady Hamilton, Mrs. Alfred
Stieglitz, G. Bernard Shaw, and the portrait group made
on Mr. George Davidson's houseboat . . ."
—Editor's note, *Camera Work* 20, October 1907

Aerial Photograph, France c. 1917
numbered "133-1"
silver, for reproduction; 8⅞ x 12¾

Sunday Papers, West 86th St., New York 1922
signed on the sheet and photographer's label verso
silver; 13¼ x 10½

Ralph Steiner (b. 1899)

American Rural Baroque 1930
signed on the mount
silver; 7½ x 9½

Alfred Stieglitz (Hoboken, New Jersey, 1864-1946 New York City)

The Hand of Man 1902
photogravure, as published in *Camera Work* 36, October 1911)

Nearing Land 1902
photogravure, as published in *Camera Work* 12, October 1905

The "Flat-iron"
photogravure, as published in *Camera Work* 4, October 1903

Katherine 1905 **P&T**
photogravure, as published in *Camera Work* 12, October 1905

Snapshot–In the New York Central Yards **V-II**
photogravure, as published in *Camera Work* 20, 1907

The Steerage 1907 **D**
photogravure, as published in *291*, 7-8, 1915

Experiment 27 (with Clarence H. White)
photogravure, as published in *Camera Work* 27, July 1909

Photogravures, as published in *Camera Work* 36, October 1911:
A Dirigible 1910 **V-I**
The Ferry Boat 1910
The Mauretania 1910

Ulli Steltser (b. Germany, 1923)

Monument Valley 1969
signed, titled and dated on the mount
silver; 13¾ x 10¾

Paul Strand (b. New York City 1890)

New York (Sidewalks)
photogravure, as published in *Camera Work* 48, October 1916

photogravures, as published in *Camera Work* 49/50, June 1917:
Abstraction–Porch Shadows 1915 **O&B**
New York, from the Viaduct c. 1915 **V-II**

Photogravures from *The Mexican Portfolio*, 2nd edition, DaCapo Press, N.Y., 1967 ("printed by Albert Delong, of Andersen-Lamb Company, Brooklyn, from steel-faced gravure plates made in 1940 by Otto Wackernagle"—from Strand's prefatory note to the portfolio):
Plate 6, ***Woman–Patzcuaro*** 1933
Plate 9, ***Woman and Boy–Tenancingo*** 1933
Plate 11, ***Man with a Hoe, Los Remedios*** 1933

Young Boy, Goudeville, Charente, France 1951 **P&T**
signed and titled verso
silver, c. 1973; 11⅛ x 9⅞

John Francis Strauss (associate editor, *Camera Work*, 1903-1910)

The Bridge
photogravure, as published in *Camera Work* 3, July 1903

Isaiah West Taber Studio (San Francisco, after 1875)

San Francisco Bay from North Point c. 1880
titled on the studio card
albumen; 7¼ x 9½

Chinatown, San Francisco c. 1880 **V-II**
on the studio mount
albumen; 7¼ x 9⅜

Edmund Teske (b. Chicago, 1911)

Portrait n.d.
signed on the mount
silver; 9⅝ x 7⅝

George A. Tice (b. Newark, New Jersey, 1938)

Woods in Port Clyde, Maine 1970
signed on the mount
two prints; silver and platinum; both 7½ x 9½

Jacquelin Thurston (b. Cincinnati, Ohio, 1939)

Seventh-Day Adventist Tent 1971
silver; 5⅜ x 4⅛

Jerry N. Uelsmann (b. Detroit, Michigan, 1934)

Apocalypse II 1967 **P&T**
signed with the monogram and dated
silver, from several negatives; 10⅝ x 13⅜

Untitled (magnolia and tree) 1968
signed and dated verso
silver, from several negatives; 13¼ x 9⅞

Untitled (window by a pier) 1970
signed and dated verso
silver, from several negatives; 12⅝ x 10

Doris Ulmann (New York City 1884-1934)

H.L. Mencken, Editor, "The American Mercury" c. 1924

Plate XXVII, *A Portrait Gallery of American Editors*, New York, 1925
photogravure

Tod, of "Nigger to Nigger" c. 1930-1932
signed on the mount
platinum; 8⅛ x 6

From "Roll, Jordan, Roll' c. 1930-1932 **P&T**
Text by Julia Peterkin, 72 photogravures from photographs by Doris Ulmann, 1933
photogravure

Underwood & Underwood, Publishers, Arlington, New Jersey

Three stereoscopic views of Mt. Tacoma, Washington c. 1890
Risky business! Peering into the awful depths of a crevasse, Stevens Glacier; Perilous climbing over ice-crags of Stevens Glacier; The sun-scarred face of Nisqually Glacier
titled in six languages and annotated on the publisher's mount, which bears the trade mark: "Sun Sculpture"
silver; each image 3 x 3

Unknown

Daguerreotypes

The Scottish Textile Worker, Damariscotta, Maine c. 1843 **P&T**
tinted; half-plate

New England Farm c. 1843 **V-II**
third-plate

View of a town near Springfield, Massachusetts c. 1843 **V-II**
third-plate

The Dead Man c. 1845 **D**
sixth-plate

Two Young Brothers c. 1845-50 **P&T**
tinted; quarter-plate

A Man and ***A Woman*** c. 1845-50
a pair; sixth-plates

Two Young Women and a Man c. 1850
tinted; half-plate

A Young Couple c. 1850-55
tinted; sixth-plate

A Young Girl with Brown Eyes c. 1850-55
tinted; sixth-plate

A Young Man with Gold Side-Whiskers 1854
dated
tinted and gilded; half-plate

Tintypes

A Young Black Woman with Silver Jewelry
c. 1860-65
tinted and silvered tintype; sixth-plate

Civil War Soldier c. 1863
tinted tintype; whole plate

Portrait of a Woman c. 1860-65
tinted tintype; whole plate

Boy with an Apple c. 1860-65
tinted tintype; ninth-plate

The Hunters c. 1865-70
tinted tintype; sixth-plate

The Stable c. 1870
tintype; half-plate

Ambrotypes

W.K. Lewis & Bros. Milk Works c. 1858
quarter-plate

Two Brothers by a Table c. 1860 **O&B**
tinted; quarter-plate

A woman and Two Children c. 1860
tinted; quarter-plate

Prints from negatives

Merrimack Manufacturing Company
(New Hampshire) c. 1860-1865 **V-II**
titled on the mount
albumen; 12½ x 16

Lookout Mountain, Tennessee
c. 1860-1865 **V-I**
titled on the mount
albumen; 3¼ x 4⅛

Chief Gabriel Reuille (Blackfoot?) c. 1865
albumen, stereogram; each image 3⅝ x 3

The 12 New York, S.M. Camp Anderson 1861/65
titled on the mount
albumen; 11⅛ x 14½

*The First Connecticut Battery, in position near
Fredricksburg* May 1, 1863
titled and dated on the mount
albumen; 9¾ x 16

*Burying the Dead–Casualties of the Battles of
the Wilderness and Spottsylvania Court House,
Fredericksburgh* May 12, 1864
titled and dated
albumen; 9¾ x 16

Wharves at City Point, Virginia July 1864
titled and dated
albumen; 6⅞ x 9¼

Washington Monument (begun 1848;
completed 1884)
albumen; 8¼ x 4⅛

River View, Englewood Cliffs, New Jersey c. 1870
titled
albumen; 9⅞ x 13⅛

Hawaii: The Volcano Halemaumau c. 1875
titled
albumen; 6¾ x 9⅜

Hawaii: Road to the Volcano from Hilo c. 1875
titled
albumen; 6⅞ x 9¼

Two views of Alaska c. 1880
Muir Glacier and *Bay near Glacier*
titled verso
albumen; both 7⅝ x 9½

A family in front of their home in the country
c. 1880
albumen; 7½ x 9⅜

Niagara–Winter
copy enlargements c. 1885 from earlier glass negatives,
(possibly by C. Bierstadt)
silver, a group of three, each 7¾ x 9⅝

A pair of portraits:
Husband and *Wife* **S**
silver, copy enlargements c. 1885 from daguerreotypes (?);
heavily retouched with gouache

*Lawn Tennis at Longwood Country Club,
Massachusetts* c. 1885
titled on the mount
albumen; 10 x 13⅝

Niagara Falls c. 1885-90
positive on milk glass; 8¾ x 6½

Views on the Jersey Shore c. 1890
a family album of 46 views taken with the Kodak No. 2
silver; diam. c. 3½

Exeter, New Hampshire c. 1890
titled verso
albumen; 5¼ x 8½

*The Lewis and Clark Exposition, Portland,
Oregon* 1905
titled and dated
silver; 9¼ x 7½

*San Francisco after the earthquake of April 18,
1906* **D**
titled and dated; sold by "O.Veneuil, Art Novelties"
silver, toned; 4½ x 6½

GAR, New Orleans 1907
titled and dated
silver; 7⅜ x 9⅝

John Vachon

*Riding out to bring back the cattle, first stages of
snow blizzard, Lyman Co. South Dakota,*
November 1940
Farm Security Administration Stamp verso,
titled and dated
silver, for reproduction; 7¼ x 9½

James Van Der Zee (b. Lenox, Massachusetts, 1886)

Studio Portrait Group 1927 **P&T**
signed and dated on the negative; studio stamp verso:
"G.G.G. Photo Studio, Inc., 109 W 135th St."
silver, toned; 8 x 9¾

R.J. Waters, Berkeley, California

Glacier Cascades (Lake Tahoe Series) c. 1880
titled on the studio card
albumen; 7½ x 4½

Carleton E. Watkins (Oneonta, New York, 1829-1916 San Francisco)

attributed to: *The Yosemite Valley, Looking down
from Union Point Trail* c. 1861-1863
published by Thomas Housearth & Co., San Francisco
titled on the studio mount
albumen; 10½ x 13⅜

attributed to: *Yosemite Valley, Mirror Lake*
c. 1861-1863
published by Thomas Houseworth & Co., San Francisco
titled on the studio mount
albumen; 15⅛ x 11⅞

*Yosemite Valley: Vernal and Nevada Falls from
Glacier Point* c. 1861-1863 **V-I**
albumen; 16¼ x 20⅝

View of San Francisco toward the Golden Gate
c. 1865-70
albumen; 8⅛ x 12¹/₁₆

Yosemite Valley: The Three Brothers after 1866
albumen; 12⅛ x 8¹/₁₆

Yosemite Falls from Glacier Point after 1875
stamp, verso: *"Watkins New Series"*
albumen; 12¹/₁₆ x 8¼

Edward Weston
Armco Steel, Ohio 1922
silver print

The Nevada Mill c. 1880　**V-II**
titled verso, and inscribed: "New Series 1054"
albumen; 15 x 21⅛

Weegee (Arthur Fellig; Poland 1899-1969 U.S.)

Drink Coca-Cola　**D**
photographer's stamp verso
silver, for reproduction; 13½ x 10½

Charles Weitfle, Central City, Colorado

Rainbow Falls in Summer, Manitou c. 1875
#115, "Stereoscopic Views on the Line of Denver &
R.I.R.R."

Bridal Veil Falls, in Summer c. 1875
#190, "Stereoscopic Views of Colorado Scenery"
both titled on the studio card, with Baedeker-like
descriptions of the particular view and of surrounding
points of interest
albumen; each image 3¾ x 3⅛

Brett Weston (b. Los Angeles 1911)

Untitled (broken window) 1966
signed and dated on the mount
silver; 9⅝ x 7⅝

Edward Weston (Highland Park, Illinois
1886-1958, Monterey, California)

Armco Steel, Ohio 1922　**p. 152**
titled, dated and signed "C.W."
silver print by Cole Weston, c. 1968-1974; 9 x 6½

Valle de San Juan Teotihuacan, Mexico
1923　**V-I**
signed, titled and dated verso
platinum; 7¼ x 9½

Guadalupe de Rivera 1924
titled, dated and signed "C.W."
silver print by Cole Weston, c. 1968-1974; 8¹/₁₆ x 7

Nude 1925　**O&B**
titled, dated and signed "C.W."
silver print by Cole Weston, c. 1968-1974; 9¼ x 6⅜

Shell 1927
titled, dated and signed "C.W."
silver print by Cole Weston, c. 1968-1974; 9⅜ x 7⅜

Neil 1929
signed, titled and dated on the mount
silver; 9¾ x 7½

Pepper 1930
titled, dated and signed "C.W."
silver print by Cole Weston, c. 1968-1974; 9⅜ x 7½

Jean Charlot and Zohmah 1933
inscribed verso: "Bk 21 #13, Man & Machine
Seq. W86 S4"
silver, proof print; 4¾ x 3¼

Dunes, Oceano 1936
titled, dated and signed "C.W."
silver print by Cole Weston, c. 1968-1974; 7⅝ x 9½

Tumble Weed, Winter, New Mexico 1937
signed and dated on the mount
silver; 7 x 9½

Untitled landscape 1937
signed with the monogram and dated on the mount
silver; 7⅜ x 9⅜

Rain—Lone Pine Peak, East Wall Sierra Nevada
1938
signed and dated on the mount, titled verso
silver; 7½ x 9½

John Adams Whipple (Grafton,
Massachusetts, 1822-1891 Boston)

Hancock House, Boston
frontispiece to J. Whipple, *Homes of American Statesmen*,
Boston, 1854
"an original Crystalotype or Sun Picture"; 3⅞ x 5

Clarence H. White (Ohio 1871-1925
Mexico City)

The Bubble n.d.
signed on the print and titled verso
platinum; 8¼ x 5½

*Illustration to Clara Morris's "Beneath the
Wrinkle"* 1904　**P&T**
photogravure, as published in *Camera Work* 9,
January 1905
signed on the plate
Photogravures, as published in *Camera Work* 23,
July 1908:
Portrait—Mrs. Harrington Mann

Drops of Rain　**O&B**
7¾ x 6⅛

Experiment 27
(with Alfred Stieglitz)
photogravure as published in *Camera Work* 27,
July 1909

Minor White (b. Minneapolis 1908)

Front Street, Portland, Oregon 1939　**p. 6**
signed verso
silver, c. 1974;

Nude Foot, San Francisco 1947
signed verso
silver, c. 1974; 6½ x 8½

Hand, San Francisco 1949
signed verso
silver, c. 1974; 1⅛ x 7⅜

Bird Lime and Surf, Point Lobos, California
1951　**V-I**
signed verso
silver, c. 1974; 6½ x 8½

*Two Waves and Pitted Rock, Point Lobos
St. Park, California* 1952
signed verso
silver, c. 1974; 9 x 11⅝

Root and Frost, Rochester, New York 1958
signed verso
silver, c. 1974; 8⅞ x 13

House, Rochester, New York 1959
signed verso
silver, c. 1974; 9⅜ x 11⅞

Capital Reef, Utah 1962
signed, titled and dated verso
silver; 16¾ x 13⅞

Coos Bay, Oregon 1963
signed, titled and dated verso
silver, c. 1974; 8⅛ x 10½

Moon and Wall Encrustations 1964　**O&B**
signed verso
silver, 1974; 9⅛ x 11⅞

Gary Winogrand (b. New York City 1928)

Untitled (from the "Zoo" series) c. 1962
signed on the mount
silver, 9¼ x 13½

Wood & Gibson (active Civil War)

*Inspection of Troops at Cumberland Landing,
Pamunkey, Virginia* May 1862　**D**
No. 16, Alexander Gardner's *Photographic Sketchbook of
the Civil War*, 1866 with the accompanying text: "Such
pictures carry one into the very life of the camp, and are
particularly interesting now that that life has almost
passed away."
albumen print by A. Gardner; 7 x 9

Thomas Anschutz
Boys swimming from a single-oared scull,
Philadelphia 1881
cyanotype

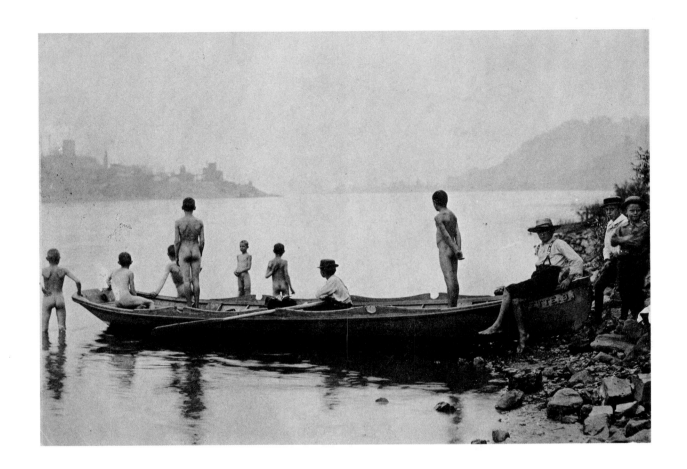

A General Bibliography

(For specific references, please see the footnotes to the introductions.)

History

Arts Council of Great Britain, *'From Today painting is dead.' The Beginnings of Photography*, exhibition catalogue, London, 1972.

C. Beaton and G. Buckland, *The Magic Image, The Genius of Photography from 1839 to the Present Day*, Boston, Little, Brown, 1975.

B. Newhall, *The History of Photography from 1839 to the present day*, New York, Museum of Modern Art, revised and expanded edition, 1964.

A. Scharf, *Art and Photography*, Baltimore, Penguin, revised edition, 1974.

R. Taft, *Photography and the American Scene, A Social History, 1839-1889*, reprint edition, New York, Dover, 1964.

Specific processes or uses

W. C. Darrah, *Stereo Views, A History of Stereographs in America and their Collection*, Gettysburg, Pa., 1964.

B. E. Jones, ed., *Encyclopedia of Photography*, New York, Arno, 1974.

G. H. Moss, Jr., *Double Exposure*, Sea Bright, N. J., Ploughshare, 1971.

B. Newhall, *The Daguerreotype in America*, Greenwich, Conn., New York Graphic Society, revised edition, 1968.

Photography of landscape

D. Edkins, *Landscape & Discovery*, exhibition catalogue, Hempstead, N. Y., Hofstra University, 1973.

W. Naef, J. N. Wood, and T. H. Heyman, *Era of Exploration, The Rise of Landscape Photography in the American West*, 1860-1885, Albright-Knox Art Gallery, Buffalo, N.Y. and the Metropolitan Museum of Art, New York, 1975.

Stieglitz and his circle

W. Frank et al., *America & Alfred Stieglitz, A Collective Portrait,* New York, Literary Guild, 1934.

J. Green, ed., *Camera Work, A Critical Anthology*, Millerton, N.Y., Aperture, 1973.

Documentary expression

W. Stott, *Documentary Expression and Thirties America*, New York, Oxford, 1974.

R. Stryker and N. Wood, *In This Proud Land*, Greenwich, Conn., New York Graphic Society, 1974.

The interpretation of photographs

N. Lyons, *Vision and Expression*, Rochester, N.Y., George Eastman House, 1969.

H. Kramer, *The Age of the Avant-Garde* (selected chapters on photography), New York, Farrar, Straus and Giroux, 1973.

J. Szarkowski, *The Photographer's Eye*, New York, Museum of Modern Art, 1966.

J. Szarkowski, *Looking at Photographs*, New York, Museum of Modern Art, 1973.

Contemporary journals

Aperture, Millerton, N.Y.; *Afterimage*, Visual Studies Workshop, Rochester, N.Y.; *Image*, International Museum of Photography at George Eastman House, Rochester, N.Y.

book design by Douglas Wadden

lithography by Cone-Heiden, Seattle, Washington

binding by Lincoln and Allen, Portland, Oregon

set in various sizes of Helvetica
and printed in duotone 200 line
on vintage velvet 80 lb. text
in an edition of 3,500
1,500 of which are clothbound